IMAGES
of America

PINE CREEK VILLAGES

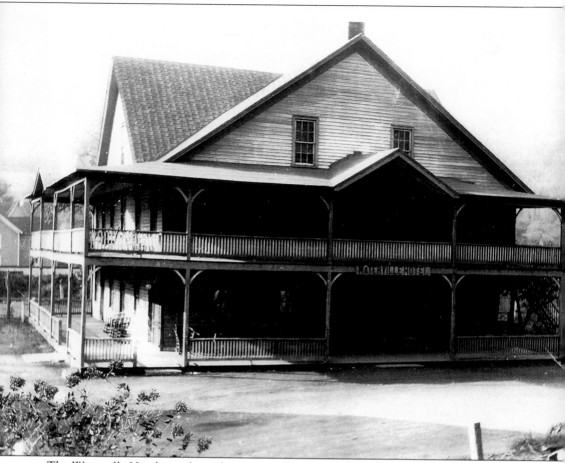

The Waterville Hotel is perhaps the most well-known and certainly one of the oldest buildings in Pine Creek Valley. Since 1825, it has served residents of and visitors to the valley. Behind it on the left is another very old edifice, the Methodist church, erected in 1850, today a private home.

On the cover: Taken in 1910 by photographer Nelson Caulkins, this view of Slate Run Village from the mountain northwest across Pine Creek shows the J. B. Weed and Company hemlock sawmill (with its two prominent smokestacks) in the center. Just north of the mill is the covered Slate Run Railroad Bridge going across Pine Creek to head west up Slate Run into the mountains. The steel truss bridge below the mill is for the road going across the creek to where Hotel Manor stands today. (Courtesy of Thomas T. Taber III.)

IMAGES
of America

PINE CREEK VILLAGES

David Ira Kagan

ARCADIA
PUBLISHING

Published by Arcadia Publishing
Charleston, South Carolina

Printed in the United States of America

Library of Congress Catalog Card Number: 2007942409

For all general information contact Arcadia Publishing at:
Telephone 843-853-2070
Fax 843-853-0044
E-mail sales@arcadiapublishing.com
For customer service and orders:
Toll-Free 1-888-313-2665

Visit us on the Internet at www.arcadiapublishing.com

*To Beth, my wife, who first introduced me
to the beauty of Pine Creek Valley.*

CONTENTS

ACKNOWLEDGMENTS

Most importantly, Wayne O. Welshans provided me with the initial inspiration to do this book. A creator of his own work in the Images of America series on nearby Jersey Shore, Pennsylvania, he convinced me that I could author a book also. And as a past president of the Jersey Shore Historical Society, he was able to provide me with some archival images to get me started.

Next a visit with Marie Kraybill in Waterville netted me a treasure trove of images. She allowed me to borrow her late husband Spencer Kraybill's entire collection of valley photographs.

A second large collection (those gathered by railroad historian Thomas Taber and now housed permanently at the Lycoming County Historical Society in Williamsport, Pennsylvania) came into my hands thanks to James Hyland's willingness to share his scanned copies with me. Most of those were 1890–1910 era images by noted valley photographer Nelson Caulkins.

Village and area residents and past residents also provided old, personal photographs (after searching through attics, cellars, closets, chests, and shoeboxes, in some cases). Those people include Vinson and Kathleen Bierly, Bertha Breon, W. Robert and Norma Camerer, George Durrwachter, Thomas Finkbiner, Allen Flickinger, Toner Hollick, Gayle Gibson Keesey, Margaret Kershner, Earle F. Layser, Neil Lehman, Barbara Maurey, Charles E. McCarthy, Glenn McConnell, Betty and Carol Miller, Dewey Oakes, Mary Paucke, David Poust, Mary Prince, Charles M. Rice, Elaine Hilborn Rice, Ruth Shipman, Thomas Stradley, and Bob and Dotty Webber.

Three Pine Creek residents, especially, need to be singled out for commendation. Kenneth O. Kelley Jr., postmaster of Jersey Mills, seemed to make it his mission to gather enough images from his tiny community to allow a whole chapter on it. Stanley Dudkin, owner of the Cedar Run Inn, had a whole album filled with marvelous old photographs, which he willingly allowed me to use. Finally Donald Blackwell provided a good number of excellent images of his namesake village.

My two greatest sources for caption information were Kraybill's genealogical and Taber's railroading and logging research.

Finally I thank my daughter Rachel for her computer assistance and encouragement and her and my two other daughters, Rebecca and Sarah, for their interest in and proud anticipation of Dad's book.

INTRODUCTION

What unites a book entitled *Pine Creek Villages?* Of course, it's that the communities all lie along the banks of the same waterway. But more importantly, it's that they share a common history.

White settlers first arrived in the Pine Creek Valley in the early 1770s, when it was truly still a wilderness area. It was also a region of the British proprietary colony of Pennsylvania that was declared by Lt. Gov. John Penn to be "off limits" to settlers. It wasn't until what was called the Second Treaty of Fort Stanwix in 1784 with the Iroquois Six Nations Confederacy that the United States government sanctioned settlement up Pine Creek.

Without a road in those early days, settlers typically made their way up the valley either on horseback or by canoe on Pine Creek. Some of those early pioneers had received land grants in return for their service during the Revolutionary War.

They made their livings lumbering, farming, fishing, and trapping. Sawmills were built, often at the mouths of runs emptying into Pine Creek. The more successful farming occurred along flat lands near the creek, where the soil was rich. Settlers found native wild trout in Pine Creek and its tributaries and whitetail deer, black bears, elk, and wild turkeys, among other wildlife, in abundance in the woods.

Some of the very earliest sawmills in the Pine Creek Valley included one built in 1793 at the mouth of Gamble's Run, just above present-day Torbert Village, Capt. Christian Stake's 1792 mill less than a mile up Little Pine Creek from Waterville and Jacob Tomb's at the mouth of Slate Run in 1792.

Early notable farmers included Henry B. Tomb (1797–1883) on his 900 acres in Tombs Run, Thomas Ramsey (1742–1813) on his 200 acres in Ramsey, and Michael Campbell (1794–1881) on his 50 acres about one mile above Cammal.

Perhaps the two most famous hunters and trappers were George Bonnell (1787–1879) and Philip Tome (1782–1855). Bonnell lived about three miles below Slate Run. Originally living at Slate Run, Tome wrote a popular book published in 1854, entitled *Pioneer Life or Thirty Years a Hunter.*

Pine Creek Valley and its surrounding mountain areas had very dense growths of two types of trees very much in demand in the second half of the 19th century—eastern white pine and hemlock. Huge numbers of the white pines were felled (especially in the 1860s and 1870s), many used as masts for sailing ships. On average slightly smaller than the pines, hemlocks were the dominant trees felled next, many in the 1880s and 1890s.

At first, the logs were sent down Pine Creek (and its major tributary, Little Pine Creek), in what were called "log drives," to the West Branch of the Susquehanna River. From there, they were floated on to the Williamsport boom, to be handled by the mills at that city.

After the Jersey Shore, Pine Creek and Buffalo Railroad was completed through Pine Creek Valley on May 9, 1883, lumbering activity took yet another turn. Now logging railroads could be constructed up into the mountains from the villages and connected to the main line through the valley.

Log drives to Williamsport began to diminish, except down Little Pine Creek where there was no railway. In the village of Slate Run, the James B. Weed and Company hemlock sawmill was constructed, along with the narrow-gauge Slate Run Railroad to the dense growths up in the Black Forest area west and north of the village.

Another smaller hemlock sawmill, built by Joseph Wood and Joseph Childs, was erected in Cammal, along with its own logging line, the Cammal and Black Forest Railroad. Second, in Cammal, another mill was constructed where creosoted wood pipe (to convey water) was made. And third, hard and small softwood was harvested for props to be used in Pennsylvania's anthracite mines, the brokers being Daniel Shepp and Charles E. Titman, with their own Trout Run Railroad eventually built to timberlands west of Cammal and the Oregon and Texas Railway up Mill Run east of the village.

As a result of all the heightened lumbering and railroad-building activity up Pine Creek Valley, its villages flourished and grew in the 1880s and 1890s, especially Cammal and Slate Run. During these prosperous times, Cammal had four hotels and three churches, Slate Run three hotels and two churches.

The village of Leetonia, seven miles northwest of Cedar Run, had its own hemlock sawmill and a hemlock bark tannery. Built by New Yorker W. Creighton Lee, the mill and tannery were isolated (with only a wagon road down to Cedar Run) until the Leetonia Railroad was built in 1899.

The last log drive down Little Pine Creek was in 1909. Weed's large sawmill in Slate Run closed in 1910. The great lumber days were ending. Pine Creek Village populations plummeted, especially in Cammal and Slate Run.

In the 20th century, Pine Creek civilization continued in other ways. There were productive farms (including dairy farms and even a turkey farm). In the two most southern Lycoming County townships along Pine Creek, Porter and Watson, significant crop farms existed.

North in Cummings, McHenry, and Brown Townships, flagging and building stones were quarried. Clay was mined in Brown Township and up in the Blackwell area in Tioga County. Ginseng, obtained from the woods where it grew wild, was grown as a cash crop by a number of residents, especially in Cammal and Blackwell.

Throughout most of the 20th century, trains continued to roll through the valley, carrying coal, freight, and passengers between New York State and locations in Pennsylvania beyond the southern terminus of Pine Creek at Jersey Shore. The tracks were finally removed in 1989, ending over 100 years of continuous train service, and ushering in the new era of the Pine Creek recreational rail-trail.

The main road through Pine Creek Valley gradually improved through the years. After the devastating flood of 1889, a number of new steel or wrought-iron truss bridges were erected (one over Little Pine Creek, the rest over "Big" Pine Creek) up the valley to Blackwell. Road paving began in 1930 with the section between Jersey Shore and Ramsey, to Cammal by 1936, all the way through to Cedar Run by 1953, but not to Blackwell until 2001.

More and more hunting camps and campgrounds appeared as the 20th century progressed, and Pine Creek Valley became what it is today—a destination for those who love the outdoors. They come to bait and fly fish, to hunt deer and bear, to canoe and kayak, to bicycle and walk the rail-trail, and to hike in the mountains. If they're lucky, they'll see an American bald eagle soaring overhead.

One

TORBERT AND TOMBS RUN

Farmland stretches almost two miles up the east side of Pine Creek from Route 220 at Jersey Shore. Then comes the first community—Torbert Village.

It does not have any stores, churches, a fire company, or a school. It is entirely residential, with somewhat over 40 homes, but its over 320 acres had belonged to just one man, James Hepburn, back in 1785.

Hepburn registered the property under the name of "Clearfield," reflecting its relatively timberless nature. He and his successors farmed the rich-soiled land. The oldest dwelling in present-day Torbert Village, the "Farm House," was probably built before 1840.

James Torbert (for whom the village was named) took over ownership from 1897 to 1913. At that time, a large barn, carriage shed, wood shed, icehouse, and a windmill-driven well-water pump were also on the property.

In 1948, the village got its start when the Torbert Land Development Subdivision was formed, and plots were laid out for dwellings.

Just a couple miles above Torbert is the village of Tombs Run. Settlement began there in 1773, when James Alexander built a cabin at the mouth of the run. By 1805, enough residents were there that a first religious meeting was conducted by a Methodist minister, Rev. John Thomas. When the township that includes both Tombs Run and Torbert Village was formed in 1845, it was named Watson Township, after the first recorded teacher in Tombs Run and later a noted banker in Williamsport, Oliver Watson.

Tombs Run was named for the Pine Creek–pioneer Tomb family. Henry B. Tomb (1797–1883) became a dominant presence in 19th century Tombs Run. Living on his father Jacob's homestead, Henry lumbered, farmed, and served as postmaster of Tombs Run from its establishment in 1851 until 1882. Henry's son Enoch (1834–1911) and then his grandson Charles (1868–1959) continued farming at the homestead.

Tombs Run had a one-room school and a Methodist church, but the school closed in 1959, and the church now stands empty also. A general store and several other businesses in the area, however, have continued into the 21st century.

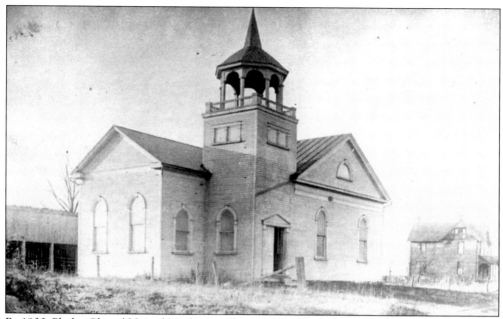

By 1900, Phelps Chapel United Methodist Church, located on the west side of Pine Creek about two miles below Torbert Village, had already been a house of worship for 45 years. Built on land donated by lumberman and gristmill owner Anson G. Phelps, the church was rededicated on May 24, 1903, after major repairs and renovations. A 1,240-pound bell was placed in the steeple on December 17, 1921.

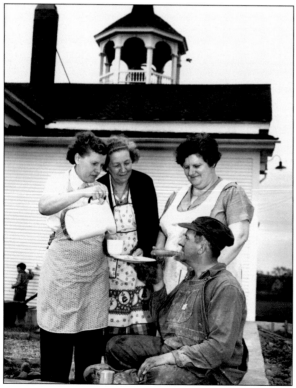

Enjoying a well-earned refreshment break in 1954 behind Phelps Chapel United Methodist Church is Carlton J. Greenaway, chairman of the building project that year that added the social hall to the church. Seen are, from left to right, Mary Bowers, Marguerite May, and Jeannette Greenaway, Carlton's wife.

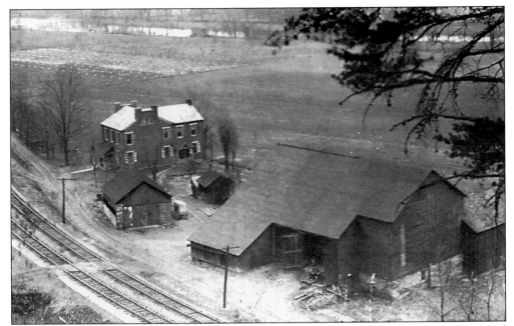

In 1925, this farm, about one mile below Torbert Village, had double New York Central Railroad tracks beside it. The historic barn was built in 1856, the house a few years before that, with a cabin there even earlier. The Maurey family bought the property in 1942 from Samuel Brown. Pioneer Andrew Fleming was reputedly shot dead by Native Americans up a ravine east of the area on Christmas Day in 1778.

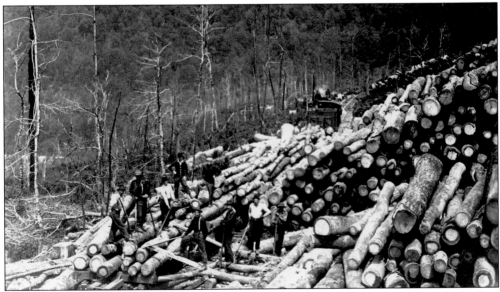

Up Furnace Run from the southern end of what is now Torbert Village, 10 men are loading Harry A. Miller's log train back between 1913 and 1916, using only their peaveys and other hand tools. The lumber, most of it second growth (as the larger hemlock had already been logged in the 1880s), was taken down the 36-inch gauge railroad to Miller's small hand sawmill about a half mile up from Pine Creek.

11

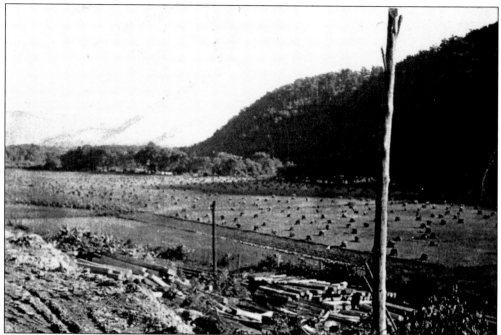

In 1926, John F. Yarrison owned 198 acres of the grounds of present-day Torbert Village. The numerous hay shocks show that it was a thriving farm then. Clearly some lumbering was also done. Pine Creek, barely visible at a few points, is at the base of the mountain. The photograph was taken from about where Route 44 now passes the entrance down into the village.

Built around 1927, this cabin (photographed in the early 1930s) was one of the very earliest homes along the banks of Pine Creek, in what would become Torbert Village. At first just a summer home of William Robert and Vasta Camerer, of Jersey Shore, it is lived in to this day by their son William Robert Jr. and his wife, Norma Doebler Camerer. Houselander Mountain above Tombs Run is visible in the distance.

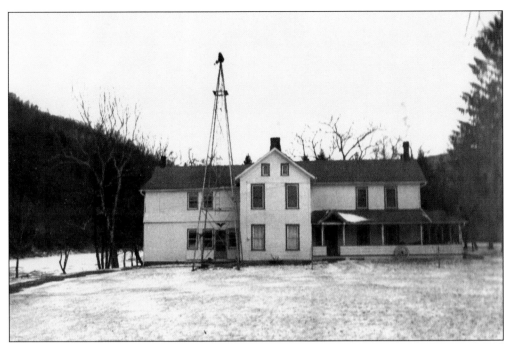

The oldest dwelling in Torbert Village, the John, then son Thomas Brown, "Farm House" was probably built before 1840. After James Franklin Torbert took over ownership in 1913, a Dutchman tenant farmer working for him, homesick for Holland (so the story goes), built a replica wooden windmill next to the house. This eventually led to the erection of a 40-foot windmill-topped tower over a well to pump water.

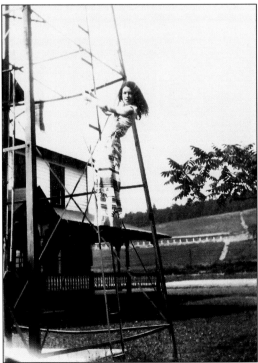

Jane Rorabaugh Spangler (1913–2007) is on the ladder of the Torbert farmhouse's tower in this late 1920s photograph. She became a noted local artist, painting and drawing many portraits of area people and images of horses, animals that she dearly loved and rode from her high school days up to age 90.

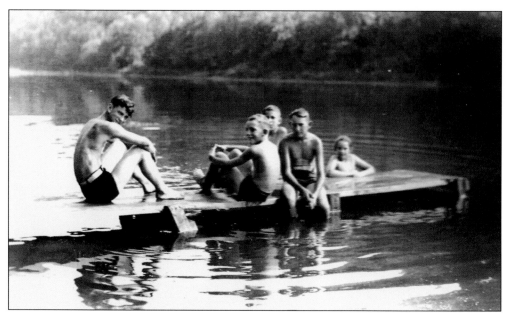

Five young people are enjoying a summer day at a pier down on Pine Creek at Torbert Village in 1933. The view is looking south. From left to right are Eugene Bay, William Robert Camerer Jr., John Bay, Fred Mick, and Agnes Mick.

Probably built by Eberhart Ellwanger about 1864, this farmhouse on the west side of Pine Creek across from Tombs Run passed into the hands of Abraham and Julia Harris in 1867, then to their children, Clyde, Eben and Perry. John and Hazel Breining purchased it in 1935, and then Allen and Patricia Flickinger in 1985. A small Tombs Run train depot once stood beside the tracks just north of the house.

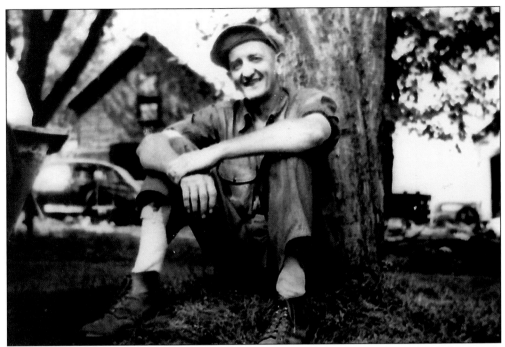

John Breining (1894–1978), in this c. 1940 photograph, is enjoying his rest against a silver maple tree on his farmhouse property just north of the railroad bridge over Pine Creek at Torbert Village. He was a veteran of World War I and then became a dairy farmer. He and his wife, Hazel, raised eight children.

This dirt road intersection is that of Routes 44 and 973 at Tombs Run before 1930, as that is the year Route 44 was paved from Route 220 near Jersey Shore up to the village of Ramsey three miles above Tombs Run. Visible on the left past the bridge over the run is the second, and later-built house on the Siegel farm property, just across the road from pastureland that later became the site of the Pine Creek Trading Post.

The Tombs Run one-room schoolhouse (on the left) closed its doors to area students by the end of the 1950s, becoming a community hall in 1959. In this pre-1913 photograph, Tombs Run United Methodist Church (on the right), erected in 1884, has no steeple. Although both structures at the intersection of Route 973 and Tombs Run Road were vacated by the 21st century, they were left standing.

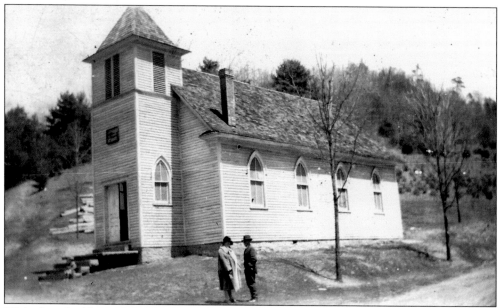

With the rebuilding of the Tombs Run United Methodist Church in 1913 following a fire, a steeple was added. Christine Siegel and Reuben Harer (born around 1864) are standing in front, not too many years after the rebuilding. Harer was the uncle of Charles C. Harer, noted 20th-century professional photographer in nearby Jersey Shore.

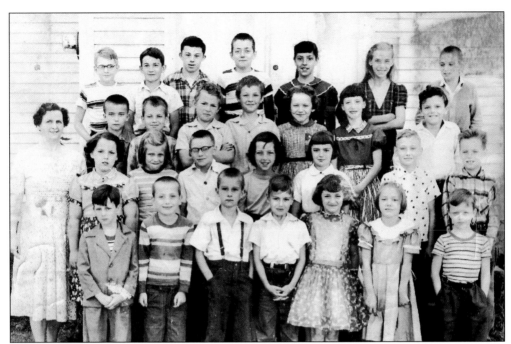

The Tombs Run School students (grades one through six) are standing in front of and on the steps of the Tombs Run United Methodist Church for their fall 1956 class photograph. Genevie Clark, their teacher, is on the left. Their one-room schoolhouse, across Route 973 from the church, closed at the end of that decade.

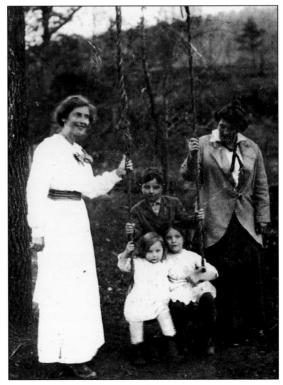

Young sisters Martha (left) and Kathryn Harer are enjoying an old-fashioned tree swing one fine day in 1913 at their Tombs Run home, where the trading post is now. Behind them is their brother, Charles, the future professional photographer. The adults are Kathleen (left) and Christine Siegel, who lived across Route 44 from the Harers.

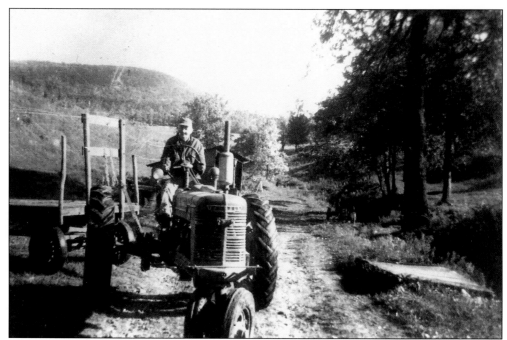

Charles Lewellyn "Lew" Tomb (1868–1959) farmed in the Tombs Run area of Watson Township. He is on his tractor probably in the 1940s, with Houselander Mountain most likely in the background. His father Enoch, grandfather Henry, and pioneer great-grandfather Jacob (beginning in 1801) had all lived at Tombs Run before him.

Tomb's hired helpers' farmhouse was down near the banks of Pine Creek. A 1940s-era, one-row corn picker is in front of the house, with a hay wagon to its right. The Laurence Zinck family was the last to reside in the house, now gone. Poust's Taxidermy now occupies this land. Route 44 is seen in the foreground.

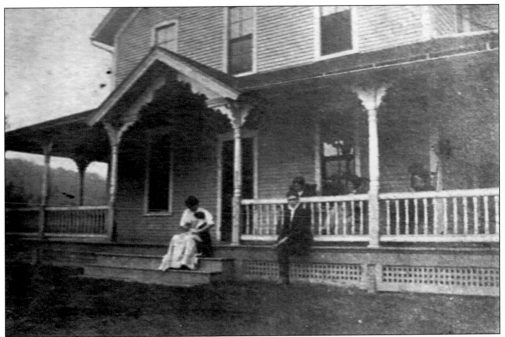

The Solomon Siegel (1846–1933) family's first-built, main farmhouse (dating from well before 1900) was erected not far from the banks of Pine Creek. Members of the Siegel household (probably children Charles, John, Christine, and Kathleen) and their dog are enjoying their front porch on a pleasant day in the late 1800s.

The Siegel family's farmhouse, barn, outbuildings, and fields dominated the landscape on the eastern banks of Pine Creek at Tombs Run during the 19th and 20th centuries. In the late 1940s, the property passed to Angus and Dorothy Miller. Their daughter Betty later became known affectionately as "the peacock lady," raising the birds at the farmstead into the 21st century, with their cries echoing in the valley.

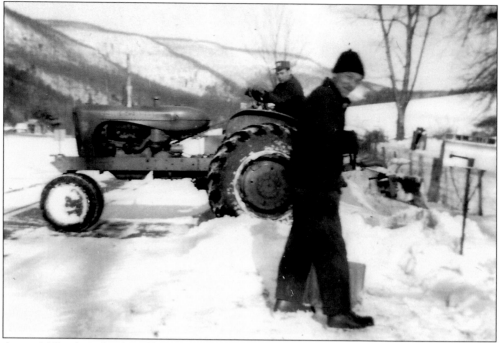

Angus Miller (standing) and his son Charles (on tractor) are seen clearing snow in the winter of 1960. They are on Route 44 by the future site of the Pine Creek Trading Post (same side as the Miller mailbox), with the mountains to the north.

From 1977 to 1982, the Pine Creek Trading Post in Tombs Run was owned by Donald Breon and Neil Lehman. They had bought the business from George Morton, and before him, it had been Bardo's (the original builder's) garage. A popular gasoline, groceries, and hunting and fishing supplies store, it entered the 21st century still thriving.

Two

RAMSEY

The history of Ramsey Village, about three miles north of Tombs Run, is to a great degree the history of the Ramsey family. Their continuous presence in the area spanned from just after the Revolutionary War until 1981, almost 200 years.

It all began when Thomas Ramsey (1742–1813), who had served as a wagon master under George Washington during the Revolutionary War, settled on Pine Creek, at the future Ramsey Village site, probably in the late 1780s. He bought 200 acres of land from a man by the name of Reese, built a sawmill, and manufactured lumber. In 1797, the Pennsylvania State Assembly designated his house as the general election voting place for Lycoming County's third election district.

Although his wife's name is lost to history, it is known that his son, Thomas Ramsey II (1772–1847), continued at the homestead, farming, lumbering, and rafting. In fact, he invented the first blade oar for steering rafts. He was married to Sarah English (1797–1875), with whom he had 12 children.

One son, Thomas Ramsey III (1821–1910), ran the village hotel, one of the stopping places for the stage, which carried mail and passengers up the creek. In 1883, Ramsey sold land along Ramsey Run to the railroad; a water tank that they built stood until the 1950s. Thomas Ramsey III married Harriet Mowery (1824–1912), and they also had 12 children.

Of these, George (1847–1934) served as Ramsey Villages's first postmaster. He also farmed and lumbered, operating a sawmill whose output was made into rafts and piloted down the river. He married Viola Whipple (1853–1914), a teacher.

They had four children, none of whom married, spending the greater part of their lives at the family homestead. Chester (1896–1940) worked in the signal department for the railroad. All three sisters, Pansy (1887–1964), Olive (1892–1974), and Elizabeth (1889–1981), were public school teachers in Lycoming County.

With Elizabeth's death in 1981, the Ramsey era ended. But the village's name and roads in the community named after the sisters assure some degree of remembrance of the family.

Ramsey Village entered the 21st century as a quiet, solely residential community. It never did have any stores or churches, and its one-room school closed way back in 1916.

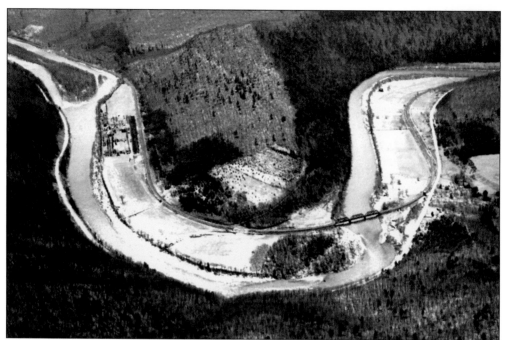

The horseshoe-shaped curve of Pine Creek at Ramsey is vividly evident from this panoramic view taken from the mountaintop southeast. Just to the right of the railroad bridge over Pine Creek is the New York Central Railroad's water tower, razed in the 1950s. On the left side of the horseshoe curve is the Boy Scout Camp Kline, with its "circular" Vallamont Theater dining hall, brought on the railroad in pieces from Williamsport in 1921.

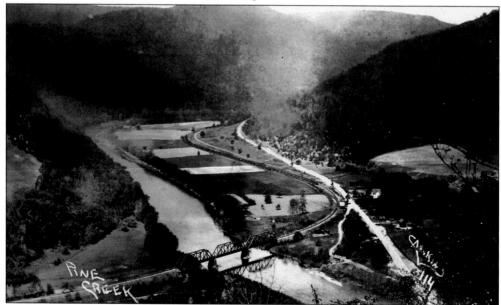

In this pre-1950s Nelson Caulkins photograph, Ramsey's fertile bottomlands are being cultivated. Later housing would sprout up to replace the fields and form the village that exists today. The bridge to the right and below the railroad truss bridge over Pine Creek is a small span over Ramsey Run. Note the multi-car train on the tracks along the fields.

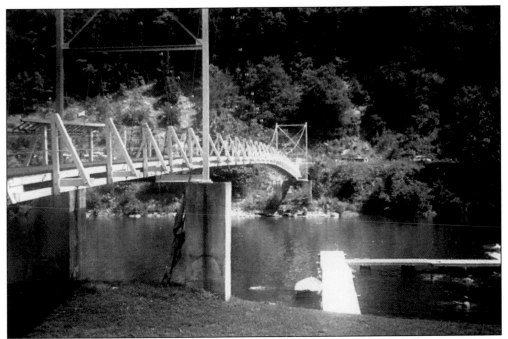

The Boy Scout Camp Kline footbridge over Pine Creek south of Ramsey swayed under the tread of many happy scouts in the summer of 1961. Built in 1955, this wire-cable suspension bridge had a 14-ton capacity and a maximum height of 25 feet over the water. On Easter Sunday, April 14, 1974, it was destroyed by extremely high winds associated with violent storms that had spawned tornadoes in the region.

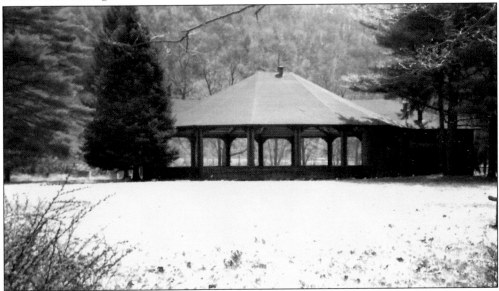

The dining hall at Boy Scout Camp Kline, just below Ramsey, was originally a dance pavilion in Williamsport. In 1921, Vallamont Theater was dismantled and sent by railroad the 25 miles to Camp Kline, where it was reassembled to serve the scouts until the camp's closure in the mid-1970s. It stood until one winter around the beginning of the 21st century, when its roof finally collapsed from the weight of fallen snow.

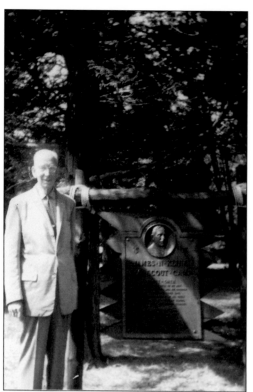

On Old Timers' Day at Camp Kline during the summer of 1962, J. Kenneth Winter, the great nephew of James N. Kline, is standing by the plaque honoring his great uncle. Kline was a Williamsport hardware merchant and Rotarian, who purchased the 360 acres of former farmland in May 1920 for use by the newly organized Williamsport Boy Scout Council.

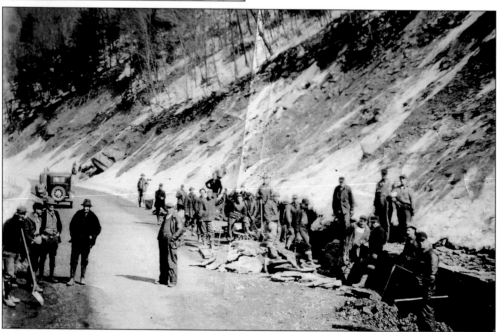

Works Progress Administration (WPA) Project No. 768 involved constructing this stone retaining wall along Route 44, about one mile below Ramsey. Among the workers are foreman Ralph Sweeley and timekeepers John E. Snook and A. H. Hilborne. The WPA was a Roosevelt New Deal agency from 1935 to 1943.

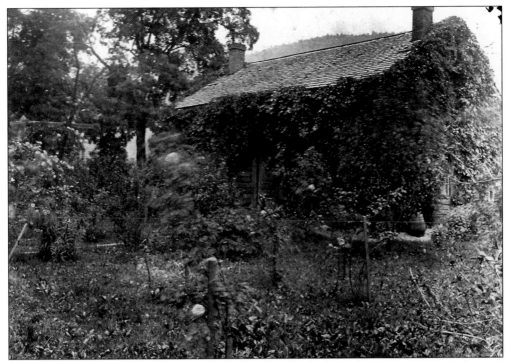

This ivy-covered Ramsey Village family cabin, possibly built in the early 1800s, was located just southeast of the New York Central Railroad bridge over Pine Creek, on the land between the creek and present-day Route 44. Possibly the first three generations of Ramseys in the area (starting with Revolutionary War veteran Thomas Ramsey, 1742–1813) lived there.

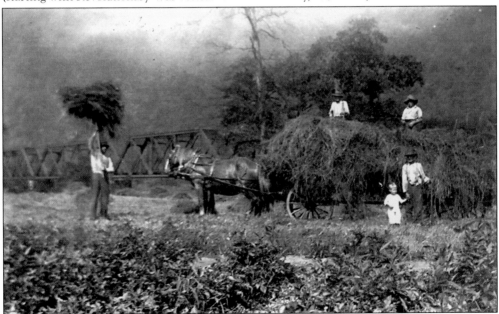

Ramsey family members (possibly George Ramsey and Thomas Ramsey III among them) are working their farmlands in the late 1800s or early 1900s. Note the railroad bridge across Pine Creek in the background.

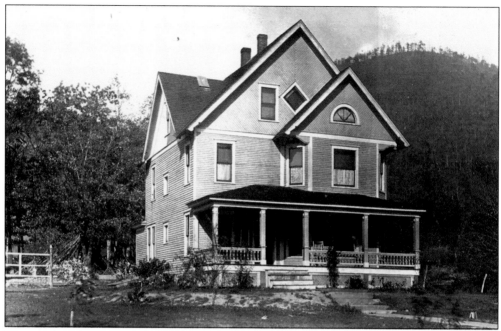

The standout house in early 20th century Ramsey Village was the homestead of the Ramsey family. In 1942, it was destroyed by fire believed caused by an overheated flue, with only a few pieces of furniture saved, and the three Ramsey sisters who lived there at the time (Elizabeth, Pansy, and Olive) escaping in their nightclothes, according to the *Jersey Shore Herald* newspaper. A replacement house was built on the site not long after.

Sheridan Grant Ramsey (1867–1939), seen on the left, and Henry E. Ramsey (1863–1933), bachelor brothers of George Allen Ramsey, are standing on the porch of their home in Ramsey Village on the hillside south of Ramsey Run around 1930. This property is now called Biegen Bach, German for "big bend," which is what Pine Creek does just south of this location, veering southwest along the base of Houselander Mountain.

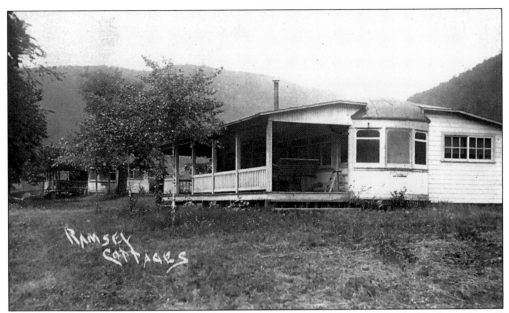

These Ramsey Village cabins were fashioned from street trolley cars, probably from the old Jersey Shore line eight miles down Pine Creek. Pansy Ramsey rented them out. They were located along Pine Creek just north of the railroad bridge, the only structures there in pre-1950s Ramsey Village.

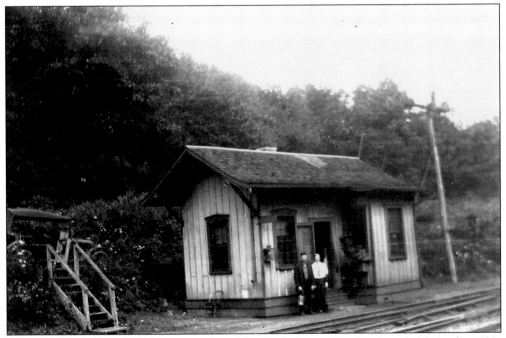

This was the Ramsey Village station of the New York Central Railroad, probably in the 1920s based on the automobile visible on the left.

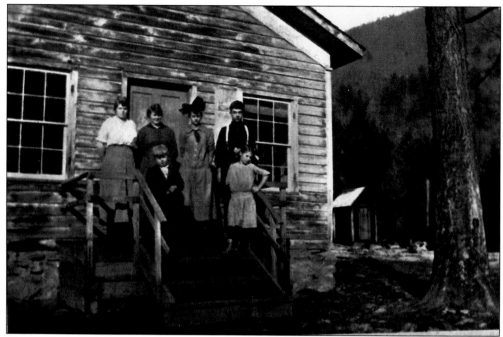

This second one-room schoolhouse in Ramsey Village by Ramsey Run opened in about 1885, after the first schoolhouse, a log building located in the "triangle" between Route 44, Pine Creek, and the railroad, closed. Teacher Mina Barrows is on the far left in this *c.* 1900 photograph, her pictured students probably including the children of George and Viola Ramsey—Elizabeth, Pansy, Olive, and Chester. This second school then closed in 1916.

In the Ramsey family's front yard, probably in the 1920s, are, from left to right, Ramsey schoolteacher Mina Barrows and her ex-students, sisters M. Elizabeth, Pansy N. and F. Olive Ramsey. The sisters were the daughters of George and Viola Ramsey. All three remained single and became teachers, Elizabeth leaving $350,000 in her will for college scholarships for "qualified students from the Pine Creek Valley."

In front of the Ramsey homestead around 1910 are Viola and her husband, George Allen Ramsey, seated in front, with Henry (George's brother) and three of their sisters, most likely Ella Mae, Jennie M., and Alice L., behind them. The siblings were great-grandchildren of Thomas Ramsey Sr., a Revolutionary War veteran. Viola was a Lycoming County teacher for 13 years.

In this c. 1930 photograph, George (1847–1934) is walking on Route 44 in front of his Ramsey Village homestead. The railroad water tower, removed in the 1950s, is on the left. Married to Viola (1853–1914), George was a sawmill operator until the passing of the lumber era in the very early 1900s, then farmed and quarried stone. From 1889 to 1914, he was Ramsey Village's first postmaster.

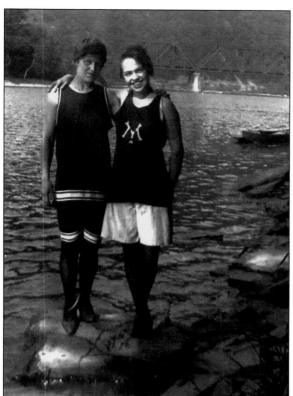

These young girls in Pine Creek at Ramsey Village show off the swimsuit styles of the early 1900s. The New York Central Railroad bridge is behind them. The bathing beauty on the left may be Elizabeth Ramsey.

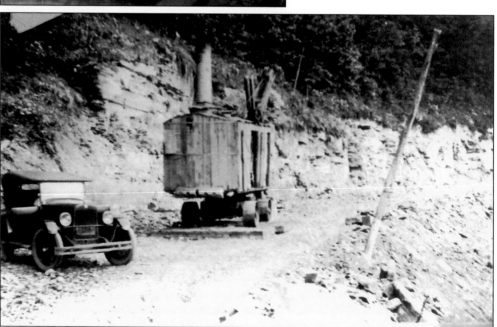

In 1926, a section of Route 44 was constructed to connect the village of Ramsey with Waterville to the north. Note the 1920s Dodge Brothers touring car beside the construction vehicle at this mountainside curve. Before this time, the road up Pine Creek Valley had ended at Ramsey Village, and the only way farther up was by the New York Central Railroad.

Three

WATERVILLE

Less than four miles north of Ramsey Village lies Waterville, at the confluence of the Little and Big Pine Creeks. The first known settler in the area was John English, another Revolutionary War veteran.

The first recorded sawmill was that of Capt. Christian Stake, built in 1792, not far up Little Pine Creek. Abraham Harris built Harris Tavern in 1825, later renamed the Carson Hotel, and then the Waterville Hotel.

The village was laid out in 1840 by Capt. James Wolf. And in July 1850, Rev. Gideon Day dedicated the Methodist church.

Throughout the 1800s, lumbering and secondarily farming were the dominant occupations of the villagers. Log drives down Little Pine Creek during the late 1800s and the first decade of the next century provided sometimes exciting and always dangerous, hard work for the men. The last drive, in 1909, was captured in images by the noted Pine Creek photographer Nelson Caulkins.

One of the more colorful people in Waterville in the early 1900s was Lottie May Wolf Wheary Wood (1876–1970). She drove a stage up and down Little and Big Pine Creek Valleys, carrying the mail and transporting passengers. In the winter, the stage was converted to a horse-drawn sleigh when snow covered the ground.

Lottie and her second husband, George Wood, also ran the Waterville Hotel from 1920 to 1923, the first three years of Prohibition. The hotel's business fell, not surprisingly, to its lowest levels during the next 10 years, prospering again under the new ownership of William and Jessie Smith at the end of Prohibition in 1933.

Other businesses in Waterville in the 1930s included Augustus Bonnell's garage, Edward Homer Love's general store, and Wolf's Hotel. Also during the 20th century, the village had Brown's and Carson's stores, Bierly's Restaurant (later the Pine Creek Valley Lodge), Asper's lumber and sawmill, and the first fire company in the valley during the 20th century.

Today the Waterville Hotel and McConnell's general store (previously Wheary's, and before that Love's) are still in business, along with the village post office.

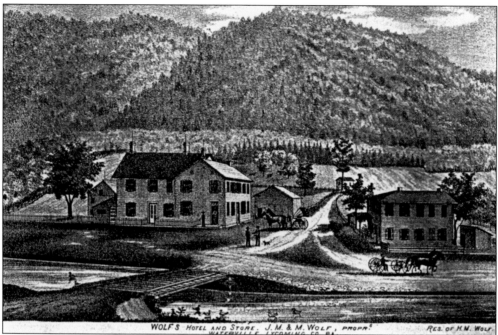

This anonymous drawing of life in late 19th-century Waterville shows Wolfs' Hotel and Store (later to become Echo Lodge), belonging to the brothers, James M. (1841–1912) and Michael (1842–1932) Wolf, who established the firm of J. M. and M. Wolf in 1873. The residence of Henry M. Wolf (1814–1905), their father, is on the right. The bridge is over Little Pine Creek, with the view looking south.

Five gentlemen are out for a horse-and-carriage ride back in 1901. The field that they are in is roughly where the Myers' house is today, at the southern end of Waterville, on the west side of Route 44 before the railroad bed. Note the outfit of the man on the far right.

Brothers Oliver (left) and Michael Wolf, of Waterville, were both Civil War veterans. Oliver (1844–1932) was wounded at Fredericksburg. After the war, Oliver farmed in the Antes Fort area, and Michael (1842–1932) went into the lumber business with his brother James M. in Waterville. Michael's daughter Lottie May Wheary Wood (1876–1970) was the first person to operate a stagecoach up and down Pine Creek Valley.

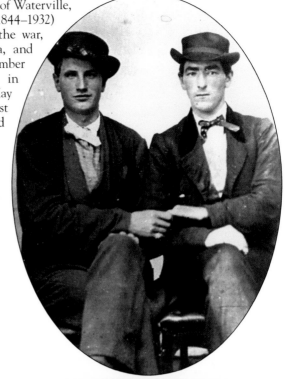

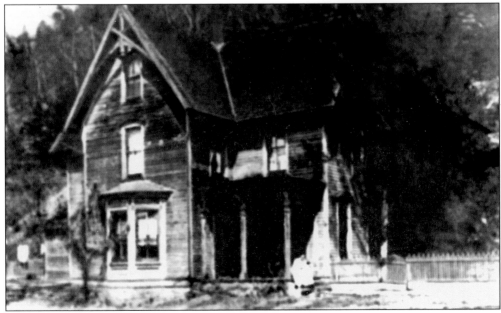

The pioneer Bonnell family had a homestead in Waterville at the point of Huntley Mountain across from the Waterville Hotel. The owner, at the time of this 1880s photograph, was Henry W. Bonnell (1845–1907). Bonnell was a Civil War veteran, seeing action at Fredericksburg with Company 1 of the 131st Regiment Pennsylvania Volunteers. Possibly his wife, Ellen Harris, is sitting on the porch with one of their children.

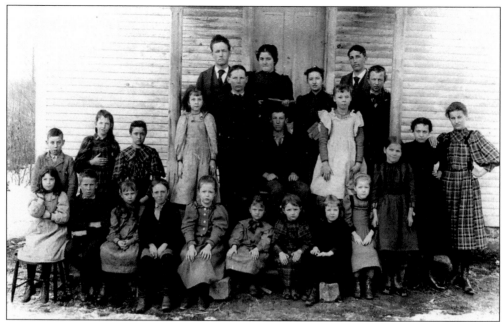

East Hill School was located up on Dam Run/Puderbaugh Mountain Road northeast of Waterville. It was one of five schools in Cummings Township around 1900, when this picture was taken. Sisters Edith (left) and Mabel Cox are likely the two standing near the middle, in the light-colored dresses. The school closed in 1915.

In about 1900, sisters Esther Blackwell (left) and Harriet Anne Love posed for the camera. Both remained single, both became teachers, and both returned often to their Waterville Love family home during summer vacations. Esther (1896–1975) taught in the Williamsport schools for 44 years. Harriet (1897–2000), an economics professor, retired from Bucknell University in 1962.

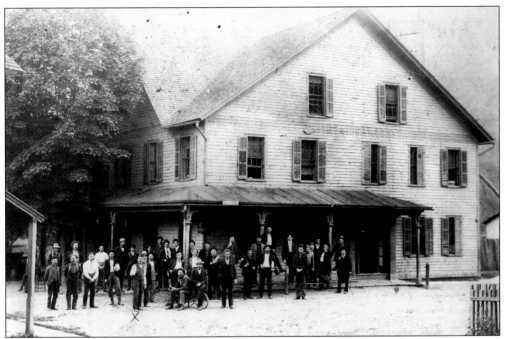

Built in 1825 by Abraham Harris, this landmark Waterville structure was originally named the Harris Tavern. Thomas Bonnell purchased it in 1869. In 1890, he sold it to Samuel Carson, and it was renamed the Hotel Carson (note sign on the building). It offered food, drink, and rooms; the third floor bunkhouse housed loggers during the 1880s and 1890s. The man marked with the "X" is Edward English, known as "One Arm Ned."

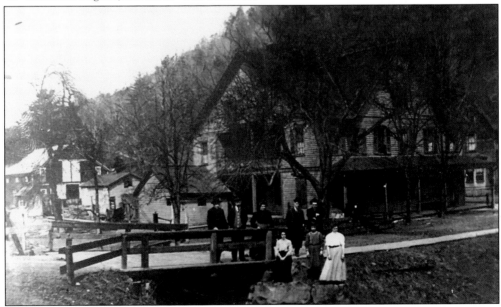

In the very early 1900s, these unidentified people gathered by the bridge that led over a drainage ditch at the rear of the Waterville Hotel. Early 20th century hunters, fishermen, and other visitors, arriving either by railroad or by stage from English Center in the east via the dirt road along Little Pine Creek, ate and slept in the hotel.

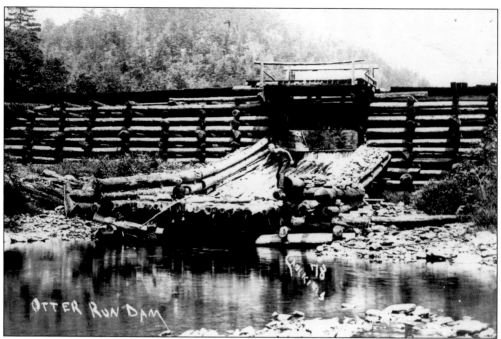

The Otter Run splash dam at Carsontown above Waterville impounded water that, when released, resulted in a "splash" and a tide of water that sent logs roaring down Little Pine Creek to enter Big Pine Creek at Waterville and on to the Susquehanna River and Williamsport. With the gate of the chute open, the men are shown repairing the dam during a summer before 1910.

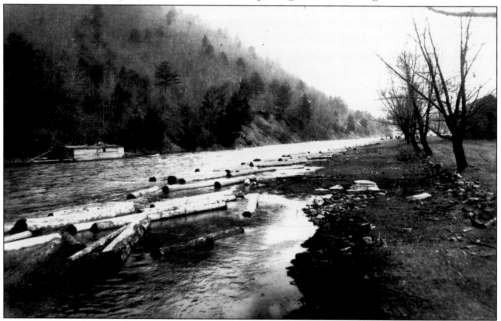

During a log drive down Little Pine Creek sometime before 1910, these logs became stranded along the banks. Lumbermen (note the crew far in the distance) working with their peaveys and teams of horses had to labor hard in the frigid water to maneuver the logs back into the main current. One of their arks lies moored along the opposite bank.

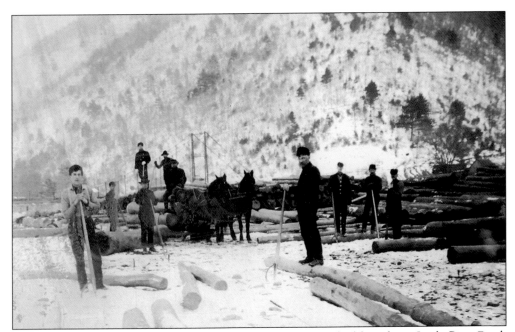

In the first decade of the 20th century, these lumbermen worked logs down Little Pine Creek above Waterville. George W. Love (b. 1865), fourth from right, and the other lumbermen are holding peaveys. Invented by Joseph Peavey of Maine in 1858, this very popular tool was a stout wooden pole about five feet long, with an iron point and a hook on its end. It was used for turning, rolling, jabbing and hooking logs, to free them from obstacles or riverbanks.

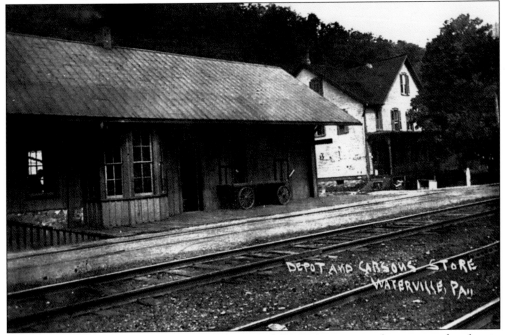

Waterville's New York Central Railroad depot and Carson's store stand next to each other in the early 1900s. The train station was dismantled by 1950. Carson's store became Camp 44 in later years.

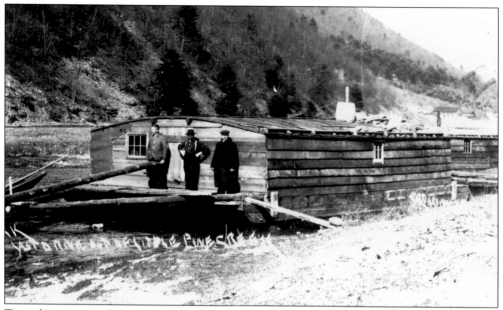

Two arks are secured along the bank of Little Pine Creek in 1909 during the last log drive down to Big Pine Creek at Waterville, and then to the Susquehanna River and on to Williamsport's mills. Three arks accompanied every drive—a dining hall, sleeping quarters, and a horse shelter. Arks were used only once, sold, and dismantled at Williamsport.

George Clarence Love (1839–1923) was a lumberman and farmer, noted for his piloting of the last ark down Little Pine Creek. His granddaughter Harriet Love, who as a child, accompanied him on that trip, wrote, "His old felt hat had the front brim turned up as usual, and his long white beard was blowing in the wind as he maneuvered the big steering oar with a skill few possessed."

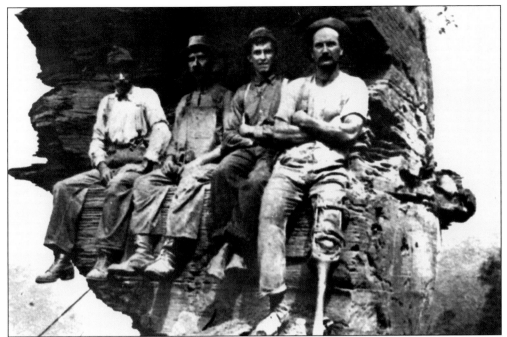

On the rock at the point of the mountain across from the Waterville Hotel sit, from left to right, Edward Linton Love, Frank Myers, Roland "Clip" Bonnell, and William "Willie" Thomas Bonnell (Roland's uncle), sometime around 1920. Roland Bonnell became a cook for the Waterville Civilian Conservation Corps camp in the 1930s. William lost his leg trying to jump a train near the Waterville Hotel.

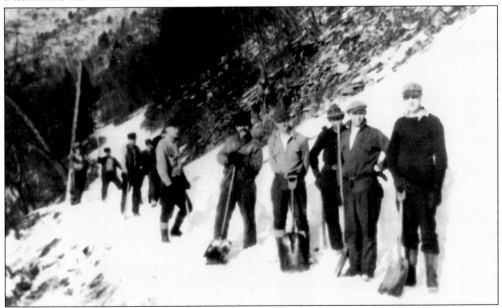

Men are removing sleet from the "old road" to Jersey Mills at the base of Huntley Mountain on the east side of Pine Creek just above Waterville (early 1930s). Bert Love is at the far left. The others identified are, three unidentified, Ralph Bonnell, Raymond Love, Clarence Myers, unidentified, Roland Bonnell, and Harrison Michael Wheary.

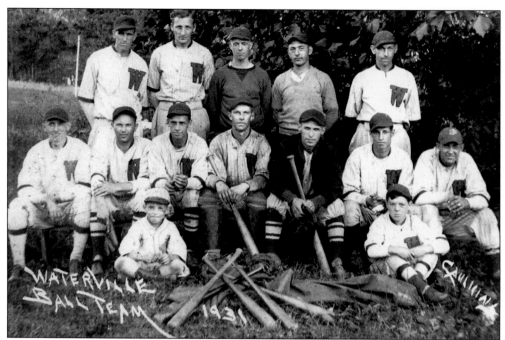

From left to right are the Waterville baseball team of 1931, (first row) batboys Jack Wentzel and Michael Frederick Wolf; (second row) David Kennedy, Charles Wentzel, Willis Garverick, Kenneth W. Crediford, Ralph H. "Tim" Bonnell, Gordon Garverick, and Donald Bowes; (third row) Robert Myers, Harrison Michael Wheary, George Willard Wolf, unidentified, and Graydon "Shooter" English.

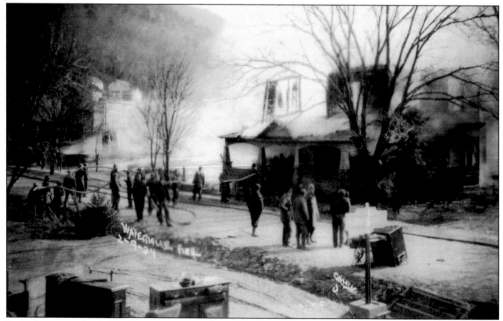

Fire devastated the Wolf residence in Waterville on February 9, 1934. The beautiful, pillared, landmark residence south of the bridge over Little Pine Creek was reconstructed and still stands today. The conflagration also destroyed several other homes, including Augustus Jacob Bonnell's.

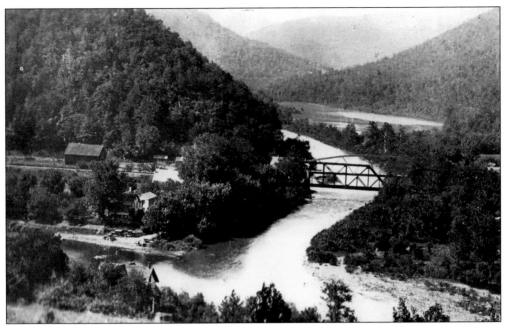

Waterville is situated where Little Pine Creek enters Big Pine Creek. In this c. 1930 photograph, the railroad bridge and, just behind it, the Route 44 truss bridge, are shown crossing over Little Pine Creek. The Bennett House is on the mountainside in the foreground, the Point House (with the 1920-era automobiles outside) is down by the waters, and the large community activities' barn (square dances held there) is on the left.

Shown in the late 1940s, the last one-room school in Waterville was closed about 1953. It was located near the present Cummings Township Building. According to Lycoming County historian John Meginness, the female teachers at this school and at the other four in Cummings Township in 1891 received $28 a month, with classes held about six months of the year.

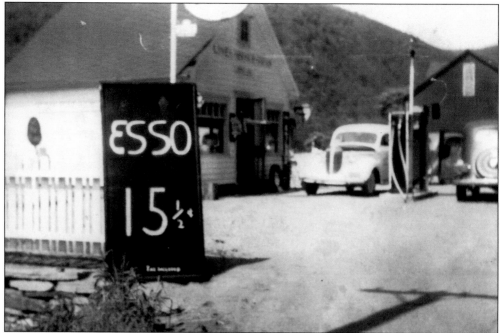

In June 1940, Edward Homer Love's general store was a flourishing business in Waterville. The automobile facing the Esso sign is a 1938 Dodge, white with a black hood—one of the first of the Pennsylvania State Motor Police's so-called "Ghost Cars." In February 1938, the police commissioner had ordered 267 passenger cars painted white with black hoods and with "PA Motor Police" lettering on the doors.

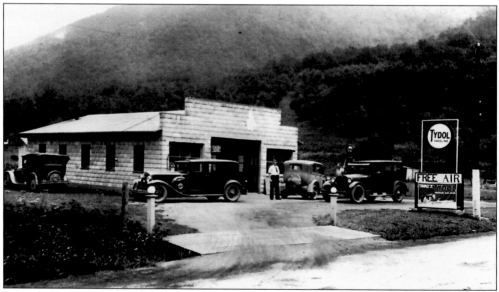

Augustus (Gus) Bonnell's garage in Waterville was located where the Pine Creek Valley Lodge was later built. Otto Campbell, in 1933, is in the center with his 1933 Packard to his right. Note the Tydol gasoline sign, advertising the era's popular brand of fuel from New York State's Tidewater Oil Corporation. In 1937, J. Paul Getty bought the company, and the gasoline became Tydol Flying A, and eventually just Flying A.

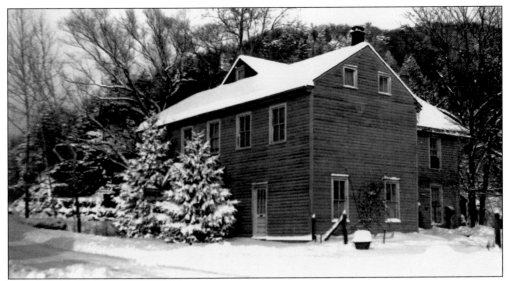

Known as the Wolf Hotel after Henry M. Wolf (1814–1905) acquired the property in the 1860s, this historical building was renamed Echo Lodge in 1945 by owner Lucy Clemons, who died in 1975 at the age of 105. It was razed in 1984, when the land was needed by the state to build the new Route 44 bridge over Little Pine Creek. The modern Waterville Post Office now sits just behind where Echo Lodge was located.

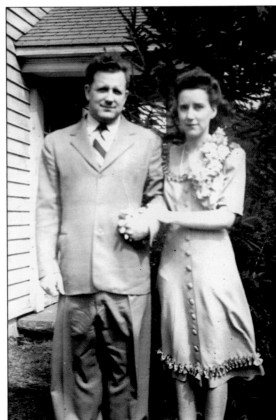

On April 1, 1944, Vinson Bierly and Alice Kathleen (Kate) Marshall were married at Echo Lodge in Waterville, posing outside the historic structure for this wedding day picture. Today the Bierlys continue to live in Waterville, only about 100 yards from where Echo Lodge was located.

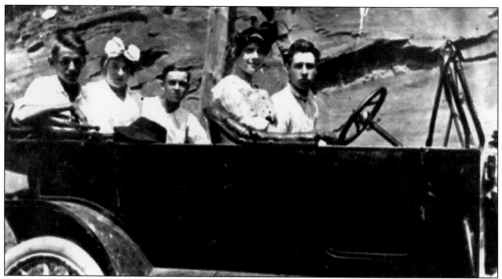

This is a *c.* 1920 photograph of what was reported to have been the first automobile in Waterville. It is believed that the young man in the middle is Edward Homer Love. The others are unidentified.

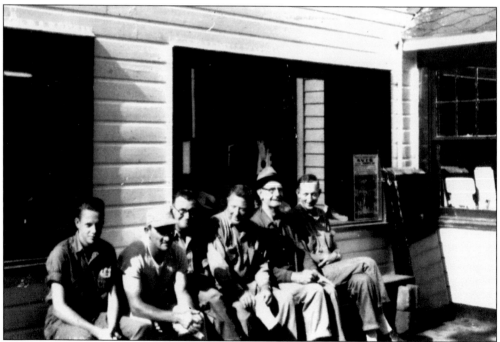

Six men enjoy a restful moment together on a bench in front of Love's general store (later Wheary's and then McConnell's) in the 1950s. From left to right are Carl Garverick, Roland A. "Clip" Bonnell, Earnest Ferrier, Charles Hilborn, Andrew Grubb, and Robert Johnston.

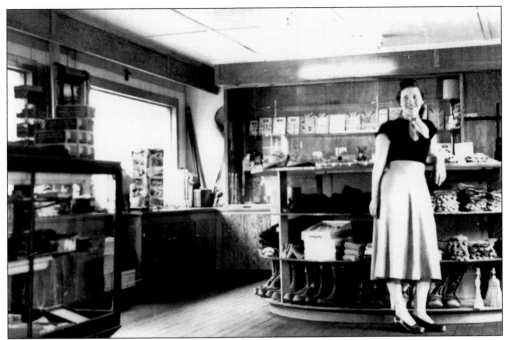

Helen English worked in Love's general store during her high school years in the late 1940s. The daughter of Graydon English and Frances E. Bonnell and the granddaughter of Augustus J. Bonnell (both the English and Bonnell families go back to the pioneer days in Pine Creek Valley), Helen went on after high school graduation to marry, raise a family, and work for about eight years for Piper Aircraft in Lock Haven.

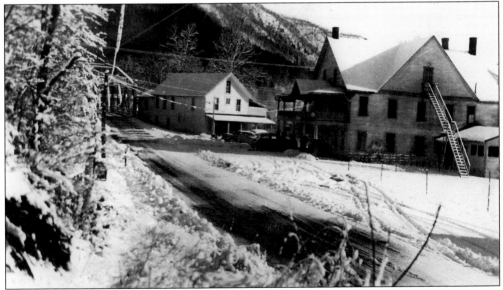

Waterville sparkled with snow during this winter in the late 1940s. Its lenticular steel truss bridge over Little Pine Creek is on the left. Next to the bridge is what had earlier been J. Allen Brown's general store, bought by Robert Yothers and lived in by his stepfather, Nelson Caulkins, the valley photographer. The building burned in the early 1950s, and many of his photographs were lost. Next is the Waterville Hotel, owned at the time by Jud Lindauer.

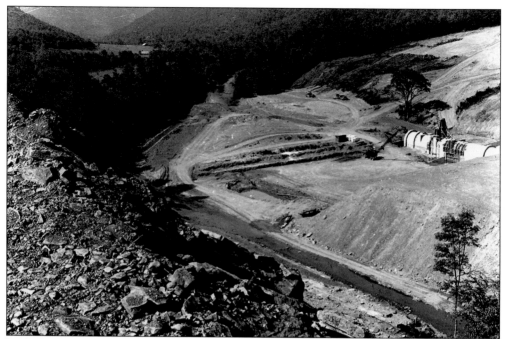

Little Pine Dam, three miles above Waterville, was constructed in 1949–1950. It was the first of the flood control dams to be built along tributaries emptying into the Susquehanna River, to help prevent losses as had occurred in the floods of 1889, 1936, and 1946. The one large tree visible in the upper right portion of the photograph was left standing so the workers could have shade while eating their lunches.

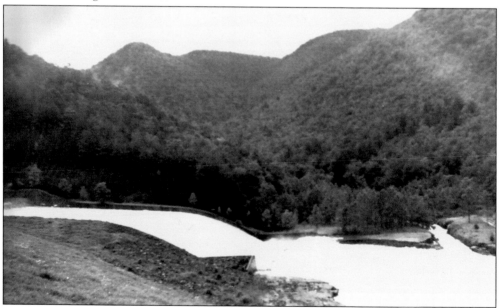

Little Pine Dam overflowed its spillway the morning of June 23, 1972. This one-time event altered the landscape below the dam. The flooding from Hurricane Agnes devastated the entire Pine Creek and Susquehanna River watersheds. It was and has remained the worst natural disaster in the state's history, killing 48 and causing an estimated $2 billion in damages.

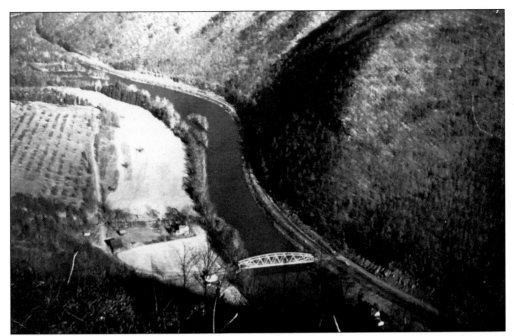

This is Pine Creek in 1950, looking north from Bull Run Lookout across from Waterville. The truss bridge was swept away during the 1972 Hurricane Agnes flood. Route 44 on the left passed by what was then a peach and apple orchard. The 1,987-foot-high Huntley Mountain (partially in shade) is on the right.

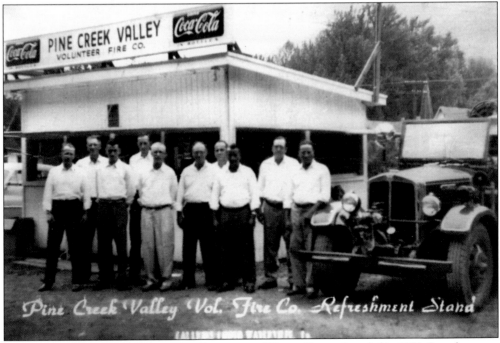

The Pine Creek Valley Volunteer Fire Company in Waterville was founded in 1952. Seen here are, from left to right, William English, Andrew Grubb, William Sawyer, Robert Johnston, Kenneth Crediford, Robert Yothers, William Smith, Edward Callahan, Nelson Stradley, and ? Rainey.

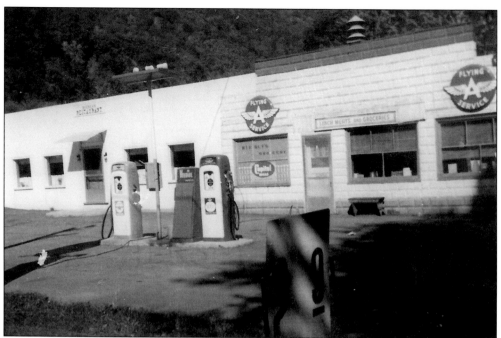

Vinson and Kathleen (Kate) Bierly owned and ran Bierly's Restaurant and Grocery Store from 1958 to 1980. Under new ownership, it was renamed the Pine Creek Valley Lodge.

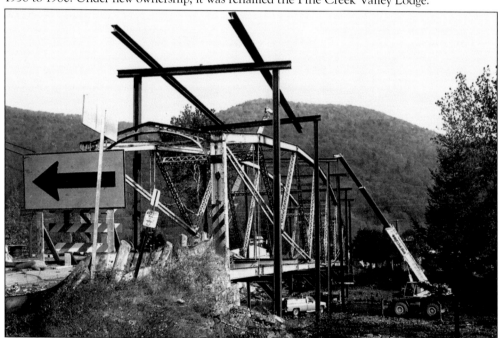

The 221-foot lenticular truss bridge over Little Pine Creek at Waterville is shown being dismantled in 1984. It was erected in 1890 by the Berlin Iron Bridge Company of Connecticut. Its unique curved top and bottom chords resulted in a lens-like distribution of stresses. Replaced by the modern concrete Lt. Michael Wolf Bridge, it was reconstructed and preserved at Swatara Park in Lebanon County.

Four

JERSEY MILLS

In the late 18th century, three men advanced civilization into the area of what would become the village of Jersey Mills, about three miles above Waterville.

Claudius Boatman, born in France, was the first white settler in the area, building a house at the mouth of Callahan Run along Pine Creek in 1785. Comfort Wanzer, who married Boatman's daughter Mary, then settled about one mile below by Dry Run. The third of these early pioneers, Abraham Harris, built on the same tract of land in 1802. Presbyterian clergyman Isaac Grier conducted the first religious services in the area in 1798. In 1804, Robert Young became the settlement's first schoolteacher. And Jeremiah Morrison built the first lumber mill in 1809.

As with all the other Pine Creek villages, lumbering and farming were the residents' main occupations throughout the 1800s. In 1848, a large, water-powered gang sawmill (where several parallel saws were placed in a frame, increasing efficiency) was built on Harris's Island in Pine Creek. Along the bottomlands, different cereal grasses were grown, including buckwheat. Crops of potatoes were also planted.

Not until 1855 was the village of Jersey Mills officially established. In that year, Levi Gisk assumed his duties as the first postmaster.

Flagstone quarrying became a source of income for residents into the 20th century. Mabel and Edward Horn's quarry up off Callahan Run was a notable operation. The Horns also had a general store and boardinghouse called the Creekside Inn in Jersey Mills. It was bought by Elmer and Kathryn Kershner in 1936, and they ran it until fire destroyed it in 1965. In 1980, the Kershners' grandson Mervin and his wife, Margaret, opened a small general store called the First Stop/Last Stop, which they ran until 2007.

Today Jersey Mills has no businesses, and the old, one-room schoolhouse closed in 1946 and has been a private home for many years. A new concrete bridge spans Pine Creek from the south into the village, replacing the steel truss bridge that had been built in 1933. Some descendants of the early settlers remain, including the postmaster, Kenneth O. Kelley Jr., the great-great-great grandson of Abraham Harris.

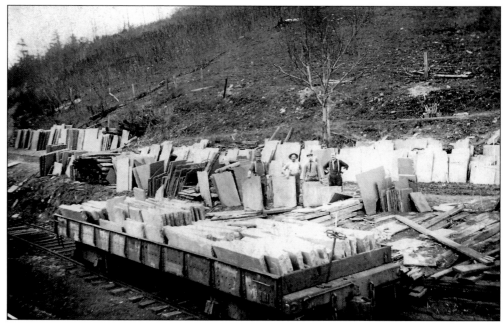

Four men are loading flagstone onto a rail car at Jersey Mills in the 1880s or 1890s. They are with the J. W. Clark and Sons stone company. John Wesley Clark, the owner and a Civil War veteran, is one of the four, but which is unknown. A number of stone companies existed in the village at that time.

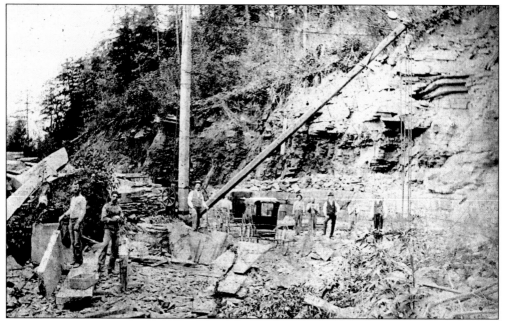

Horn's flagstone quarry was off Callahan Run Road northeast out of Jersey Mills. They sold their stone to a man named Barr in Shamokin. In this *c.* 1900 photograph, Harry S. Clark is the second from the left. Others include Edward Horn (the quarry owner and possibly the man to the left of the buggies), S. Carson, and a "Jake" (the latter two's positions in the picture are not known). Perhaps Horn's wife, Mabel, took the photograph.

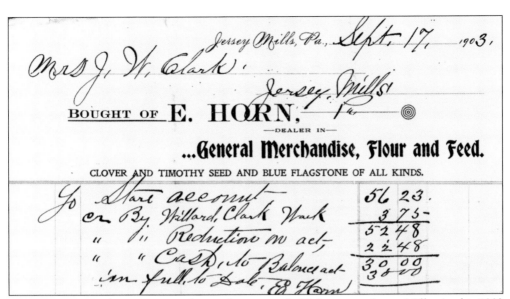

Horn was apparently a very versatile merchant in early 20th century Jersey Mills. As this 1903 receipt to Mrs. J. W. Clark shows, Horn dealt in general merchandise, flour and feed, clover and timothy seed, and blue flagstone.

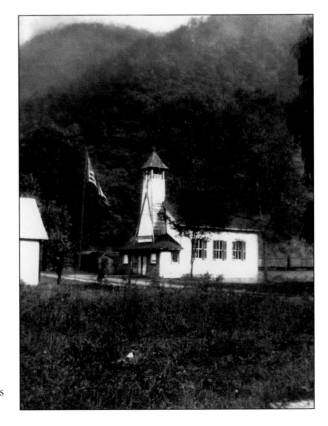

This is the Jersey Mills schoolhouse in 1926. Its bell tower blew down sometime before 1940. The school closed in 1946. Some of the teachers were Joshua Reynolds, Gertrude Moore, and Helen Hilborn. Today it remains as a private residence.

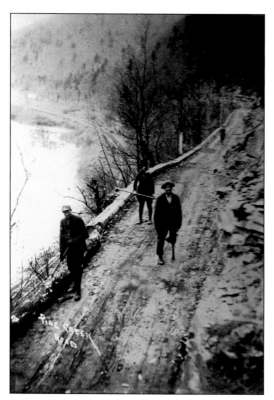

These men are doing roadwork sometime in 1928–1929 along the old road on the east side of Pine Creek between Waterville and Jersey Mills. Obviously a very rugged road, it only averaged 10 feet wide, with a 60- to 70-foot drop at times to the railroad below. Because of its red shale base, driving along it during or after rains could be very treacherous.

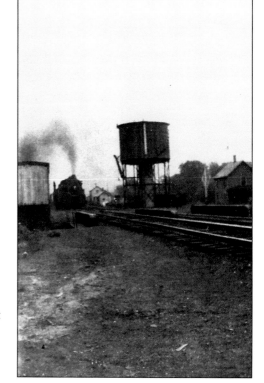

In September 1930, a train came steaming past the Jersey Mills' water tower from the south. The main track with siding, double-bridge crossing is over Callahan Run. The siding and water tank were removed in 1951.

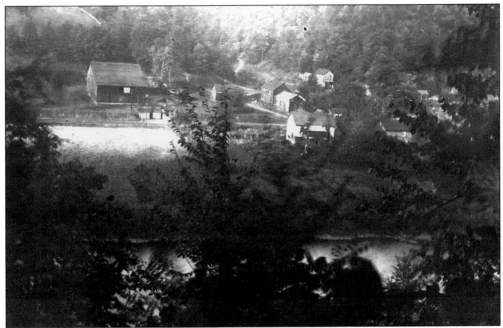

This is a view of the village of Jersey Mills around 1925 from the mountain west across Pine Creek. In the upper left is the large barn of the Reynolds' farm (Callahan's before that), with the New York Central Railroad station directly in front of it. The Reynolds' farmhouse is the large house with the white siding, with a granary and horse barn above it, and the Moore home beside it.

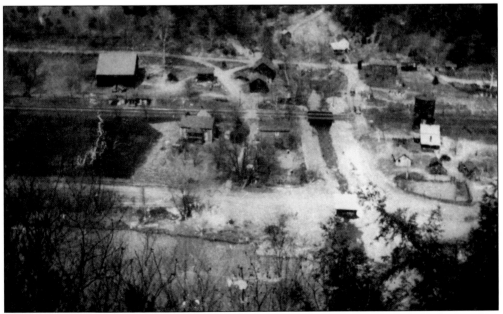

In this c. 1945 photograph of Jersey Mills, Callahan Run is shown flowing down into Pine Creek. Also notable are the New York Central Railroad's water tank and bridge over the run. Just to the left and below the railroad bridge is the Moore family homestead, which has housed the post office since 1972. The road bridge over Callahan Run down near Pine Creek was built in 1936.

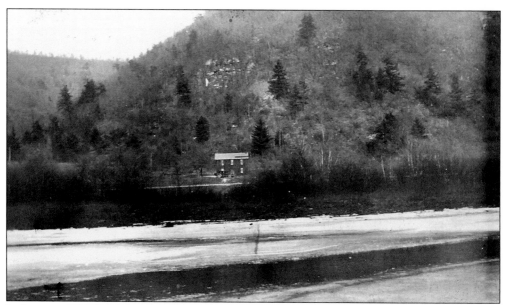

In January 1931, Pine Creek at Dry Run just below Jersey Mills was partially covered by ice. The Clark/Kelley "old house" (built in the 1870s by John Wesley Clark, a descendant of the pioneer Callahan family) is across the creek, with the logged off hillside behind just starting to show regrowth.

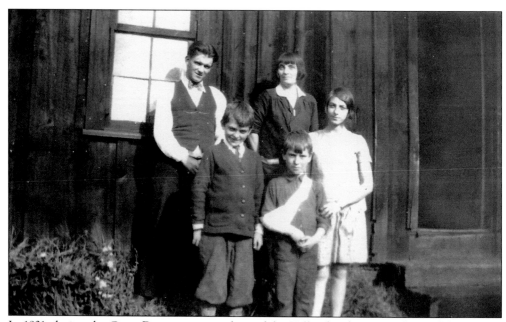

In 1931, during the Great Depression, members of the Kelley family pose in front of their Jersey Mills "old house." In the back on the right is Clara H. Clark Kelley (daughter of John Wesley and Frances Harris Clark). Kelley's children are, from left to right, Truman Saam, Hoyt, Kenneth (with the broken arm), and Blanche.

This is Pine Creek just south of Jersey Mills in August 1930. The New York Central Railroad (NYCRR) stone mile-marker is most likely L-154, just below Dry Run. The "L" stands for Lyons, the town 154 miles north in New York State, where the north-to-south branch of the NYCRR originated.

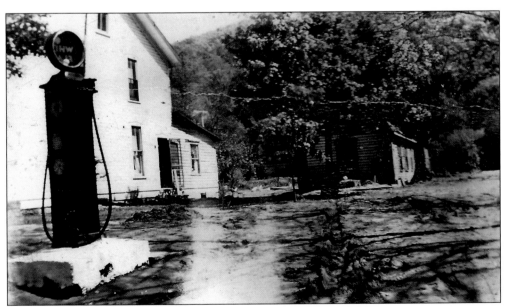

The Creekside Inn and General Store was owned first by a Bonnell, then by Edward H. Horn beginning in 1909, and finally by Elmer and Kathryn Kershner as of 1936. It was destroyed by fire in 1965. It stood just north of Mervin (Elmer's grandson) and Margaret Kershners' First Stop/ Last Stop business, the village's next general store, from the mid-1970s until its closure in 2007.

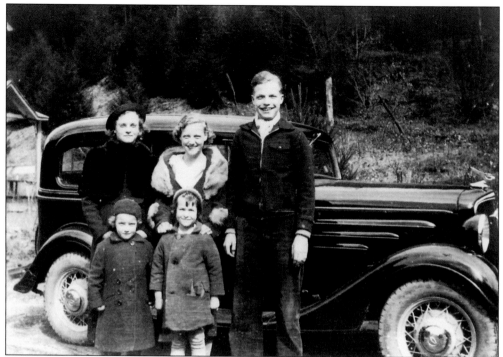

In front of a mid-1930s Chevrolet two-door sedan are five young Jersey Mills people. From left to right are (first row) Glovie Woodhouse and Patricia Perry; (second row) Gertrude Woodhouse, Edith Woodhouse Kershner, and Harold Woodhouse.

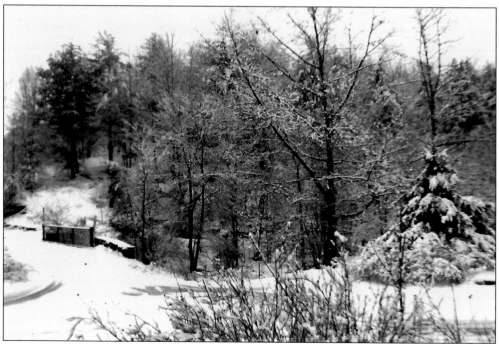

This is the small road bridge over Callahan Run in Jersey Mills during the winter of 1934. It was built in 1905 and replaced in 1992.

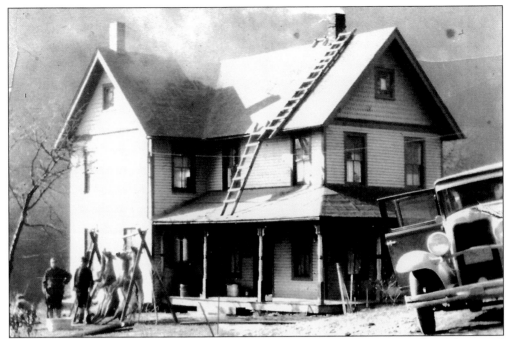

On December 12, 1931, the George W. and Lydia Esther Watts Gibson home at "Bluestone," about two miles above Jersey Mills, had deer hanging out front and ladders going up the roof for repairs. In those days, rooms were available for hunters and fishermen, and there was a speakeasy in the cellar. Later it became known as the Gibson Hotel.

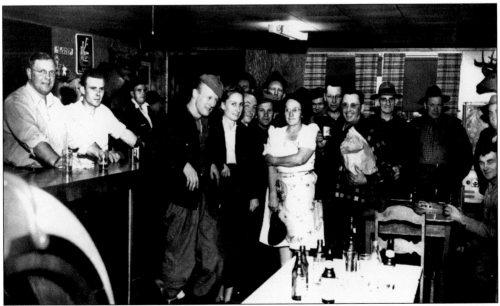

During deer hunting season in 1948, the Gibson Hotel was a busy place. The owners were Esther Gibson (1891–1976), standing in the center and holding the hat, and her husband, George Gibson (1886–1951), on the far right, sitting and holding a glass. Note the Wurlitzer "Bubbler" jukebox at the lower left; post-war America was the "golden age" of these coin-operated, phonograph record-playing machines.

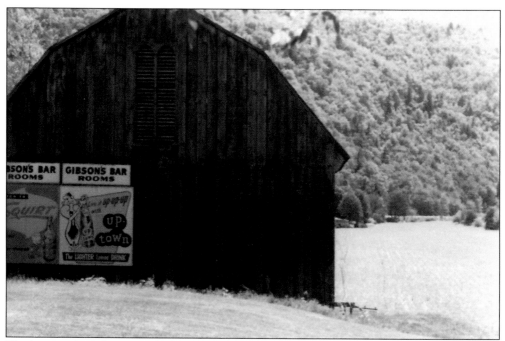

The barn at the Gibson Hotel advertised two popular carbonated drinks in the 1950s. Up-Town was produced until 1966 by Faygo, a company started by two Russian immigrants to Detroit in 1907. The cartoon character visible in the advertisement and seen on television commercials was called "Herkimer the Bottle Blower," who was "too pooped to participate" until he drank Faygo Up-Town pop.

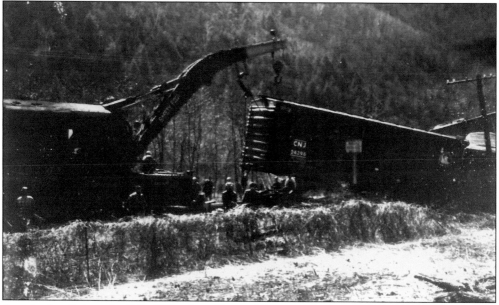

A train derailed on April 2, 1968, along Route 414 near the mouth of Truman Run two miles north of Jersey Mills. The car about to be moved has "CNJ 24396" printed on its one end and a logo that includes an image of the Statue of Liberty on the other. This car belonged to the Central Railroad Company of New Jersey (CNJ), a company that existed from 1839 to 1976.

Five

CAMMAL

Five miles north of Jersey Mills, the village of Cammal once bustled with lumbering activity rivaled only by the village of Slate Run six miles further north. With its Wood and Childs hemlock sawmill, wood pipe mill, and mine prop operations, Cammal prospered at the end of the 19th and beginning of the 20th centuries.

Although the postal village of Cammal was not established until 1884, with James Lomison as its first postmaster, the pioneer Campbells (whose contracted name became that of the village) arrived well before that. In the second decade of the 19th century, Michael Campbell settled about one mile north of Cammal, farming there his whole life. Abner and George Campbell, his brothers, built a mill on Mill Run.

As with all the communities on Pine Creek, the advent of the railroad days in the 1880s and 1890s elevated an era of subsistence living to one of prosperity. After the construction, in the early 1890s, of three logging railroads connecting to the New York Central at Cammal (much of the work done by Italian laborers), much timber was felled and transported down the mountains.

The community flourished. A number of stores arose to serve the needs of the expanded population. The village's four hotels and their bars were very busy places. The Baptist, Primitive Baptist, and Methodist churches were filled on Sundays. An Odd Fellows lodge was established in 1891. There was a weekly *Pine Creek Pioneer* newspaper.

But the high times did not last long. Joseph Wood and Joseph Childs closed their mill in 1905. The great lumber years were coming to an end. Cammal did survive through the 20th century, however, with some of its residents growing ginseng as a cash crop in the 1920s through the 1940s, a number of families providing room and board for hunters and fishermen every year, and others working for the railroad, the highway or forestry departments, or at jobs in larger communities in north central Pennsylvania outside the Pine Creek Valley.

Today, although there are no active churches and its post office closed in 2002, Cammal does have a general store with rooms to let, a bar and restaurant, a fire department, a campground, and a community center.

In front of their Cammal home in this *c.* 1895 photograph are, from left to right, William Alonzo Hostrander, his sisters Charity Hostrander Campbell and Mary E. Hostrander Splann, his granddaughter Fannie R. Hale, possibly a step-granddaughter Emma Maffet Leinbach, and his daughter Nancy Hostrander Hale.

The DeLong residence in Cammal in this *c.* 1910 photograph later became the Tall Timbers hunting camp. On the porch are, from left to right, Clarence Adelbert DeLong, Nellie Marguerita DeLong (Clarence's daughter), Elijah M. DeLong (Clarence's father), Zoe A. DeLong (Clarence's daughter), and Gertrude Amelia Fiedler DeLong (Clarence's wife).

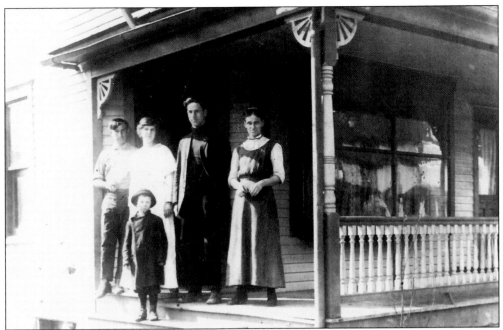

Trimble family members are relaxing on the porch of their home in Cammal around 1915. In front is Edward. In back are, from left to right, John, Elizabeth Griggs, Arthur Norman, and Fannie E. The three boys are all brothers, Elizabeth is Arthur's wife, and Fannie is the boys' mother and wife of James H. Trimble. Fannie later ran a grocery store in Newberry, Pennsylvania, where her husband, James, was killed in a buggy accident in 1931.

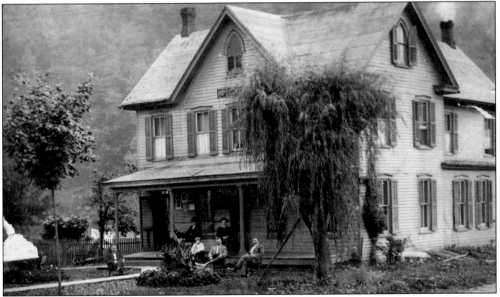

Relaxing in front of Cammal's north end Pine Creek House Hotel in about 1910 are, from left to right, D. Edward Splann, Walter Campbell, lad J. Bruce Campbell (who went on to be a train dispatcher for the New York City Railroad), unidentified older man with long beard, Amos B. Hostrander, and Judson Rodger Campbell (a justice of the peace, the McHenry Township tax collector, the owner of a store in Cammal, and the father of J. Bruce).

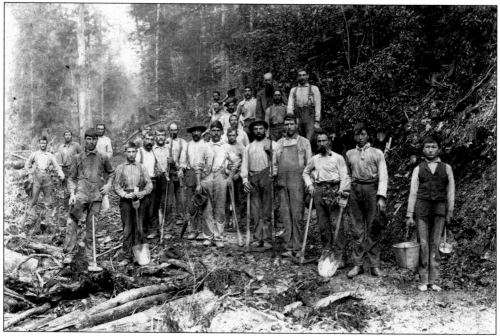

With just picks, shovels, and sledgehammers, this Italian railroad construction crew dug a roadbed for a new spur line of the Cammal and Black Forest Railroad. Note the water boy on the right. In the late 19th century, Italian immigrants obtained jobs with Pennsylvania's railroads through the *padroni*, labor agents who sometimes even paid for their ocean passage over; in return, the rail laborers paid a portion of their wages to the padroni.

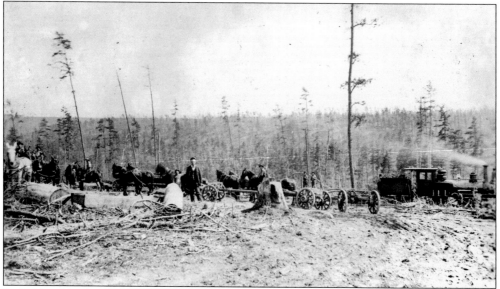

Probably taken around 1894 near the oil pipeline pump station in the mountains northwest of Cammal, this picture shows Shay (Ephraim Shay had developed his small, but powerful, namesake locomotive in the late 1870s in Michigan) engine No. 258 waiting while a load of mine prop timber is brought in by the horses and wagons. The loaded trains then steamed down Daniel Shepp's 42-inch narrow gauge Trout Run Railroad the 10 to 12 miles to Cammal.

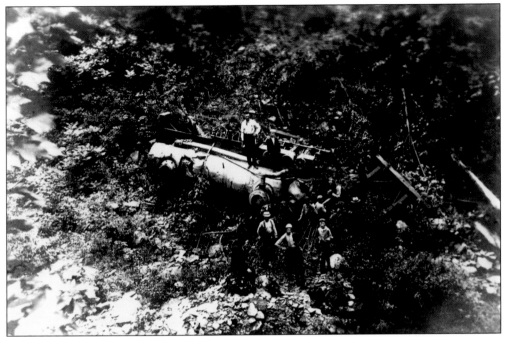

On June 14, 1900, 40-ton Shay locomotive No. 383 plummeted, along with its three cars, about 300 feet down a steep embankment to the Bull Run stream area below. It had been returning from the Okome mountain lumbering area back to the village of Cammal. Attributed to a combination of wet tracks, failed sanders, and the exceptionally steep 10-percent grade, the worst wreck to ever occur on a Pennsylvania logging railroad left seven persons dead.

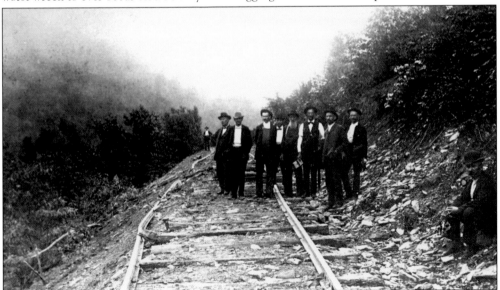

The S-curve behind the men was too much for the speeding, out-of-control Shay No. 383, and the start of its disastrous tumble down the Bull Run embankment is marked by the ripped up tracks. Titman's Oregon and Texas Railway (which had been in operation since 1892 taking out anthracite mine prop timber) did not fare so well after the accident; in fact, within three months the rails were removed, and the era of the Oregon and Texas Railway came to an end.

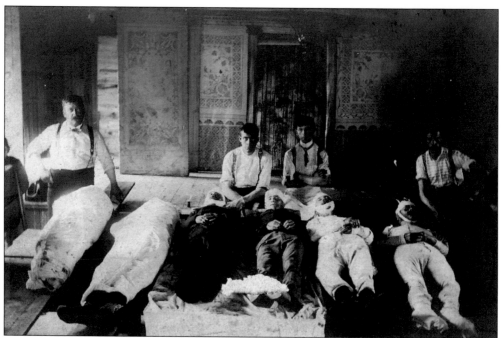

The victims, and those attending to them, are shown in this photograph of the aftermath of the June 14, 1900, train wreck. Once the train was traveling pell-mell down the tracks, with a steep drop to the right and a hillside immediately to the left, those still on board had no reasonable options. The ones who jumped against the hillside were flung back against the cars and killed; those who stayed on board perished in the awful descent to the canyon floor.

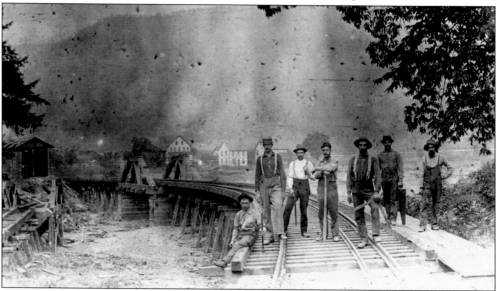

Around 1895, a new "triple rail" line was completed from Cammal (some houses visible across Pine Creek) through the covered bridge (on left) up Trout Run two miles to the First Big Fork. There the Trout Run Railroad's narrow gauge ended, with the standard gauge of the Cammal and Black Forest Railway continuing to Pump Station. At left is the dismantled trestle of the old narrow gauge track.

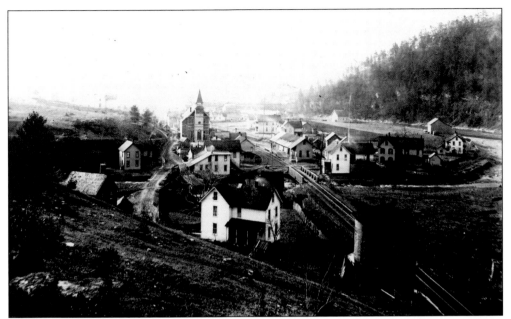

This view of the northern end of Cammal in the 1890s shows the Baptist church, the railroad station, Thomas Bonnell's Pine Creek House Hotel (just above the "pointer" at the top of the water tower by the tracks), and the Oregon and Texas Railway, a logging railway (named after two Lycoming County mountains east of Cammal), branching off to the left to go six miles up Mill Run.

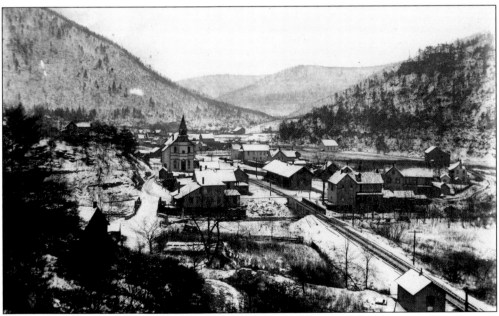

In this later, very early 20th-century photograph, the tracks of the Oregon and Texas Railway are clearly gone. The railway had ceased operations after the June 14, 1900, train wreck. Another disaster struck almost 30 years later when, on March 28, 1928, the Baptist church (near the center of the photograph) burned down, along with nearby houses.

65

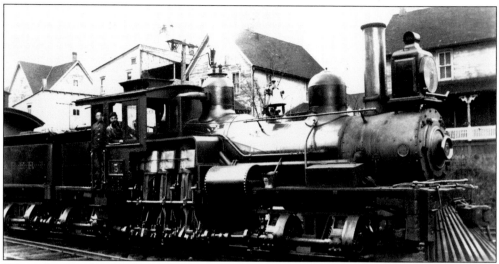

When the Joseph Wood and Joseph Childs' sawmill in Cammal was ready to commence operations in 1895, this three-truck, air brake–equipped, 65-ton Shay No. 5 was purchased. It traveled along the Cammal and Black Forest Railroad across a covered bridge over Pine Creek, west up Trout Run, and finally up to 4,000 acres of timber on Manor Fork Run in extreme northwestern Lycoming County.

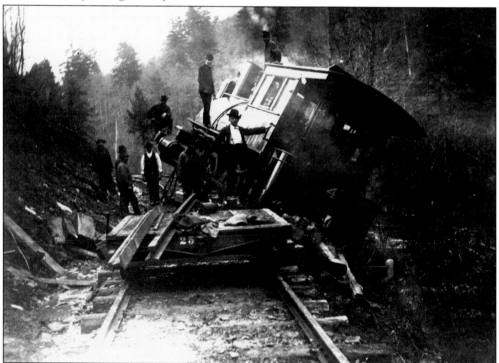

In 1894, the recently incorporated Cammal and Black Forest Railroad bought a second-hand, rod engine, saddle tank locomotive, No. 4, to assist in construction work. It was the only rod engine in the entire Pine Creek lumbering area. "Saddle" refers to the inverted u-shaped water tank draped over the boiler. Here the locomotive derailed, barely avoiding a tumble down the embankment.

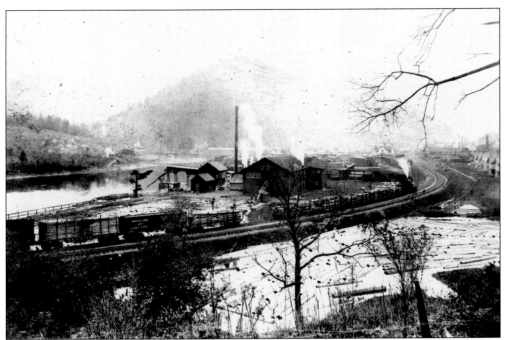

In 1894–1895, Wood and Childs built a small sawmill at the south end of Cammal. Their Cammal and Black Forest Railroad, incorporated in 1894, brought lumber to the mill from the forests west and north of Cammal and Pine Creek. The covered Cammal and Black Forest Railroad bridge is visible behind the mill's smokestack. Constructed to cut 30,000–40,000 feet daily beginning July 1, 1895, the mill closed in 1905.

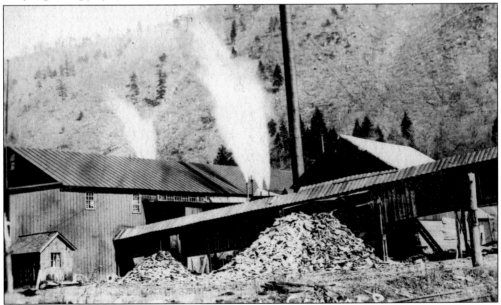

Wood and Childs' mill had a covered structure held up by wooden piles, leading from the sawmill to Pine Creek. Inside was a conveyor that carried wood waste to be dumped into the creek. Area historian Thomas Taber learned that children in Cammal had played on the conveyor until the day that "one child didn't get off in time and was killed."

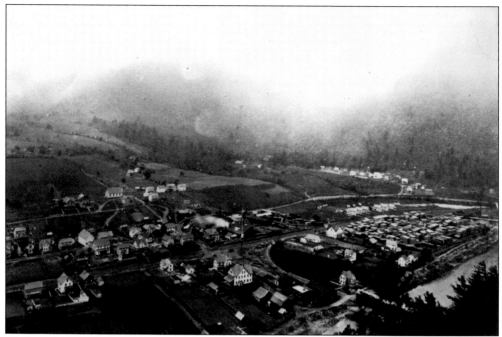

The southern end of Cammal in 1903 had two active industries—the Joseph Wood and Joseph Childs sawmill (at the right, with its piles of lumber) and the creosoted wood pipe mill (at center, smoking above the "Y" in the railroad). The Cammal and Black Forest Railroad's covered bridge crosses Pine Creek. Adjacent to its village-side end is the railroad shop (elongated, dark building) and Hamilton Campbell's elaborate, white-fenced home.

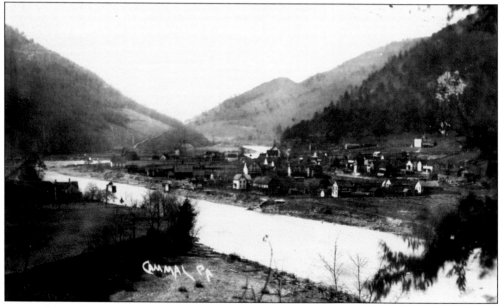

Cammal in 1910 just had open fields at its lower end, where the Wood and Childs lumberyards and sawmill (razed in 1905) had been. And just the piers remained from the covered railroad bridge that had crossed Pine Creek. Add to all this the lack of trees in the village, and the picture is a sad one indeed after the great lumber era of the previous decades.

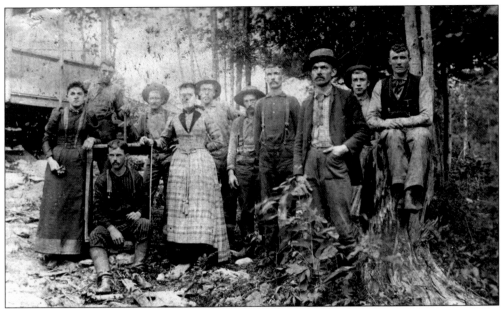

These men and two women posed during a Sunday outing in the mid-1890s at Titman's lumber camp near Cammal. From left to right are Blanche White, Major Davis, Frank Barton (seated), Jake Baylor, Laura Brion, Samuel Brion, Huey Gibson, Leslie Brion, Alvin Callahan, Harry Brion, and Charles Brion. The "wood hicks" (the commonly used term for the loggers who actually cut the timber) exhibit a variety of dress.

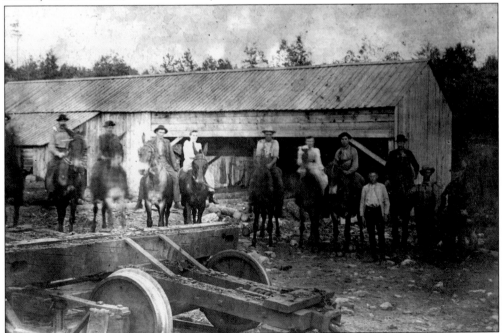

Seven men and two women are apparently either preparing for or returning from a horse ride around Titman's lumber camp in the mountains above Cammal. People on these Sunday outings were transported up to and back down from the camps by a passenger car on the rear of a logging train.

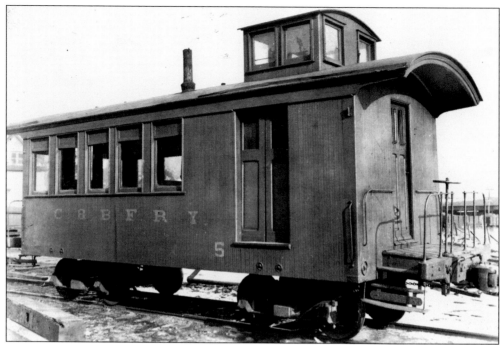

A Cammal and Black Forest Railroad caboose passenger car was at the end of every train. It carried people and supplies to the camps, telegraph stations, and other stops along the 22-mile-long route. In 1900, two trains ran daily except Sunday, with official timetable stops listed for Trout Run Junction (although that line had been torn up before 1900), Cannon Hole, Wilcox Camp, Ranstead, Boyer, Summit, Pump Station, Herritt, Slate Run Junction, and Tioga County Line.

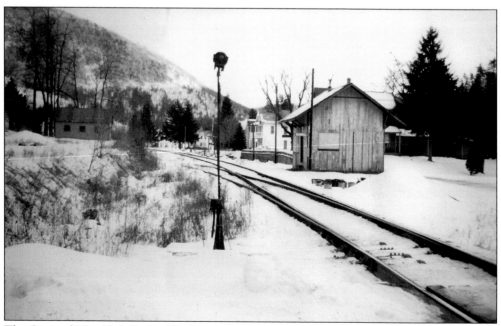

The Cammal New York Central Railroad train station was a modest structure at the north end of town.

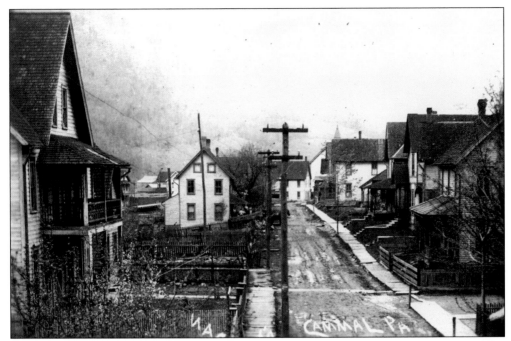

Cammal had board sidewalks and power lines in 1904. Electricity was provided by the generator at the creosoted wood pipe mill in the village. When the mill closed in 1905, the lines were taken down, and coal oil lighting made its return. Electricity did not recommence until 1940.

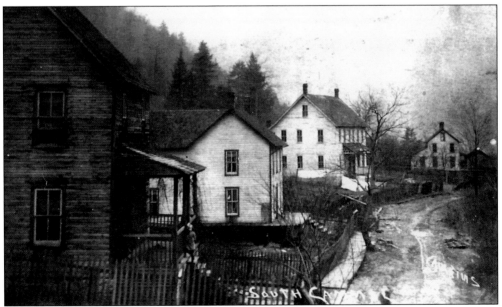

This southeastern end of Cammal was known as "Skunk Town." It got this name because of all the foul-smelling skunk cabbage that grew in the vicinity. The little girl on the front steps of the first house appears to have spotted the photographer, Nelson Caulkins, as he took this photograph probably back around 1910.

This farm of Lorenzo Dow Campbell (1844–1917) and then of his son, Abner J. Campbell (1877–1973), was on the west side of Pine Creek, opposite Truman Run at Bluestone, between the villages of Jersey Mills and Cammal. Those in the photograph are unidentified, but it is known that Lorenzo was also a lumberman and owned several stone quarries, and Abner was a member of the Primitive Baptist Church in Cammal.

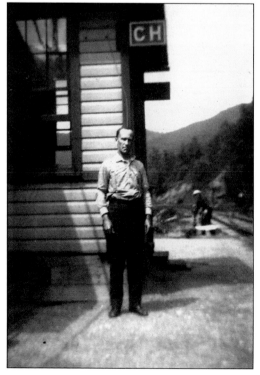

Clarence Adelbert DeLong, around 1915, stands beside the New York Central Railroad's CH (Childs) Tower at the train switching area just below the south end of Cammal. It was here that he was tragically killed in 1918, struck by a southbound train on the second track after handing a message to a northbound one.

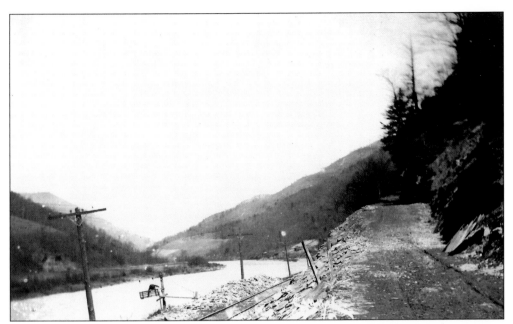

In this early 20th century photograph, the road north out of the village of Cammal is a narrow dirt and stone ascent, with no side railings. To the left are the New York Central Railroad tracks and telegraph poles. A man is up in the "cage" of the pedestrian cable crossing of Pine Creek.

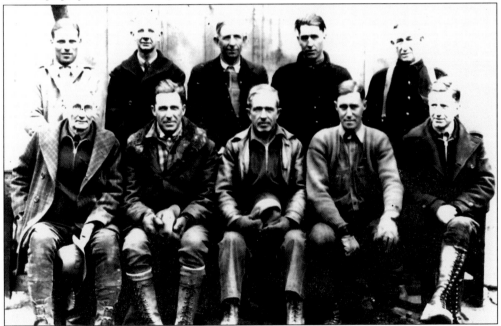

Civilian Conservation Corps forestry foremen at Cammal Camp 124 in 1933 are, from left to right, (first row) Col. ? Lovelace, Harold Coolidge, Wellington Elliot, Truman Campbell Jr. (became a bridge inspector for the New York Central Railroad), and Bruce Campbell; (second row) George Durrwachter, ? Thompson, Grover Stradley (became a maintenance foreman for the New York Central Railroad), Earnest Ross (became a bridge man for the New York Central Railroad), and Jonathan Watts.

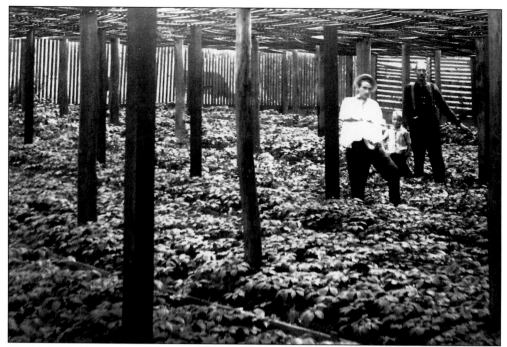

Shedric Henry Stradley (wearing suspenders) is in his ginseng gardens in Cammal around 1940. During the heyday, 1920s to 1940s, Chinese buyers from Philadelphia would come to Cammal by train to purchase the tuberous roots. The half-dozen or so growers in the village received very good money for the prized root, valued for its supposed medicinal and aphrodisiacal qualities. Originally, the ginseng was found growing wild in the woods around Cammal.

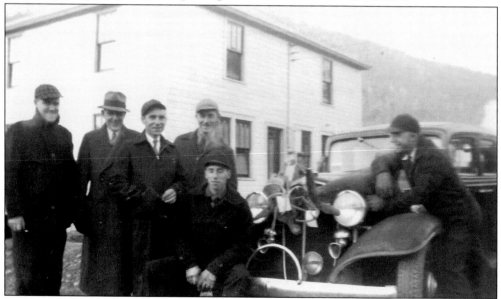

On December 8, 1941, the day after the Japanese attack on Pearl Harbor, these six hunters gathered in front of the newly opened Cammal General Store of Donald and Vivian Miller, who ran it for 25 years. From left to right are brothers Clyde, Norman, and Harry Reynolds; Andrew Connell; and brothers Clarence (sitting on the automobile's bumper) and Raymond Rosazza.

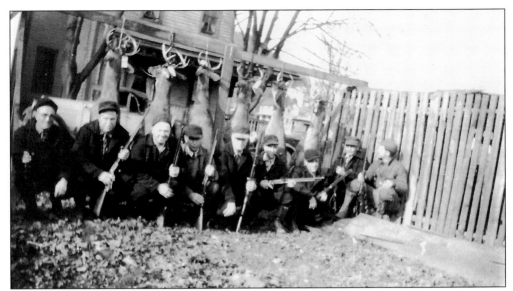

Orin M. and Gertrude Amelia Fiedler DeLong Campbell, in addition to running a general store in Cammal, also took in hunters at their home during deer season. This group of men from Perkasie, Pennsylvania, who came year after year to the Campbells' place, in the fall of a year in the mid-1940s, have bagged their six deer, the camp limit in those days.

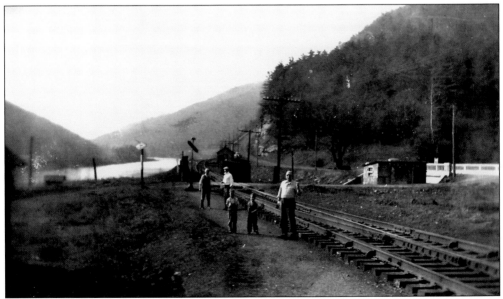

About 1946, two young boys, Andrew Bilby (left) and George Durrwachter, stand beside the railroad tracks at the north end of Cammal with Capt. Charles J. Norman and a couple of other unidentified adult friends behind. The railroad bridge is over Mill Run, with a tin shanty to the right by the access road. Rail traveling hobos, if they were caught, would stay in the shanty overnight.

Built about 1930 by the Odd Fellows Society, this building (shown during winter sometime in the 1950s) served also as a Cammal Community Church full-time until the mid-1970s. The Odd Fellows (the village chapter ended in the mid-1940s) used the top floor, renting the ground floor to the Methodist congregation, with the basement reserved for a social hall. Today it is being renovated to function as a community activity center.

This homestead at Ross Run about a mile above Cammal was used as a state forestry employee residence until 1989. It is near the "Golden Spike" site, where on May 9, 1883, engines came together from both directions and blew their whistles in salute to each other, marking the completion of the Jersey Shore, Pine Creek and Buffalo Railroad through the valley.

Six

SLATE RUN

Slate Run, the second major lumber-era village on Pine Creek, had the James B. Weed and Company hemlock sawmill. Actually, there was an original Weed mill built in 1886 and a second mill in 1893, replacing the fire-destroyed first.

Even the first, with its daily output capacity of 60,000 feet, dwarfed the Wood and Childs' mill in Cammal, which could only cut 40,000 feet a day. Weed's second mill had a large gang saw that increased output capacity to 100,000 feet each day. Also, Weed's mill ran for 24 years (1886–1910), whereas Wood and Childs' only operated for 10 (1895–1905).

This celebrated Pine Creek village had its beginning when pioneer Jacob Tomb (1758–1814) paddled his family in canoes up Pine Creek in 1791 and settled at the mouth of Slate Run. By the next year, he had erected both a sawmill and a gristmill. Daniel Callahan, an Irishman and noted hunter, arrived not long after to build a homestead at Black Walnut Bottom, less than two miles south of Tomb's homestead. In 1806, the first school was opened, also at Black Walnut Bottom, with Scotsman John Campbell as the teacher.

John Wolf, a blacksmith, was another early-19th-century settler in the Slate Run area. Yet another pioneer was George Bonnell, who farmed and lumbered at the mouth of Bonnell Run, a mile below Black Walnut Bottom.

In 1885, a post office was established at Slate Run, with Rosa Tome as its first postmaster. Carson's general store (which also housed the post office) and Wolf's (later Cohick's) Mountain House Hotel were two popular commercial establishments. Both a Baptist and a Methodist church served the religious needs of the community.

Both Slate Run and Cammal had covered railroad bridges over Pine Creek during the great lumber days. Slate Run, in addition, had a steel truss road bridge (built 1902) over to the west bank.

Today Slate Run no longer has any churches (the Baptist church burned down in the 1930s and only some foundation and steps are left of the Methodist church), its school closed in 1959, and only an overgrown field exists where Weed's great mill was 100 years ago. But as with the other villages, Slate Run has survived and does have two very popular thriving establishments, Wolfe's General Store (with an active post office inside) and the Hotel Manor (with rooms, restaurant, and bar).

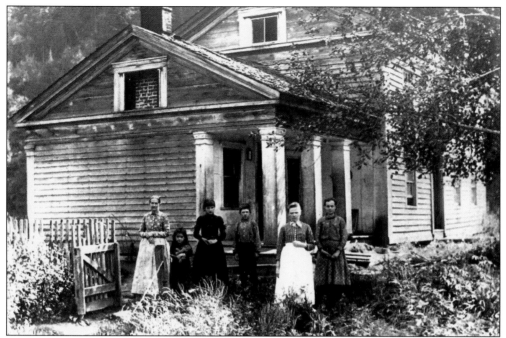

Pioneer George Bonnell (lumberman, hunter, and trapper) built this homestead three miles below Slate Run during the first decade of the 1800s. From left to right (around 1890) are Elizabeth Beauvier Bonnell (daughter-in-law), Charlotte Diehl (Elizabeth's granddaughter, raised by her because her mother, Angelia Bonnell, died giving birth to Charlotte), Mary Jane Bonnell (Elizabeth's daughter), James Bonnell Jr. (Elizabeth's son), unidentified, and Cora Campbell Raemore (a Bonnell family friend).

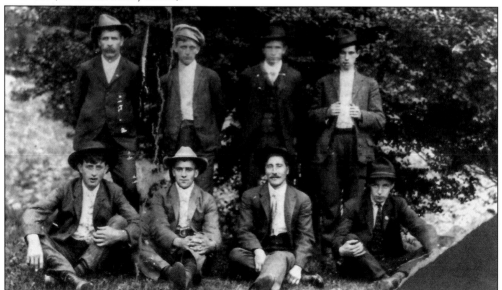

On the Fourth of July in 1905, some of Slate Run's men folk are enjoying each other's company. Seen are, from left to right, (first row) John Campbell, ? Brown, Elmer ?, and Harry Hostrander (1887–1940); (second row) Henry Stradley (born around 1852), James Powell, Grover L. Stradley (1885–1950, Henry's son), and John L. Trimble (1887–1980).

Standing are, from left to right, Eva Marie, William Horton, and Susan Jane Tomb, with their brother James Benjamin seated, all born in the 1860s in Slate Run to Matthew Grant and Rosa Cline Horton Tomb. Eva was a teacher, William was a laborer, Susan was a dressmaker, and James was a telegraph operator. William also wrote stories about 19th century life in Pine Creek Valley.

In 1908, in front of their homestead in Slate Run are, from left to right, siblings Emma Tomb (1888–1933); George Garfield Tomb (1885–1971), who owned hundreds of acres of land along the mountainside off present-day Route 414 north of Slate Run; and Eliza Tomb (b. 1883). They were great-great grandchildren of the pioneer Pine Creek Valley settler Jacob Tomb. George's son Ralph Melvin Tomb continues to live at the homestead today with his wife, Janet.

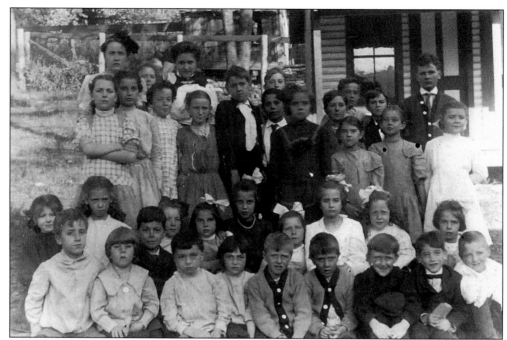

During the lumber era, Slate Run was overflowing with school-aged children. These students and their teacher are posing for a school picture around 1905, standing beside the school (the structure still exists at the south end of the village, above the rail trail). It closed around 1960.

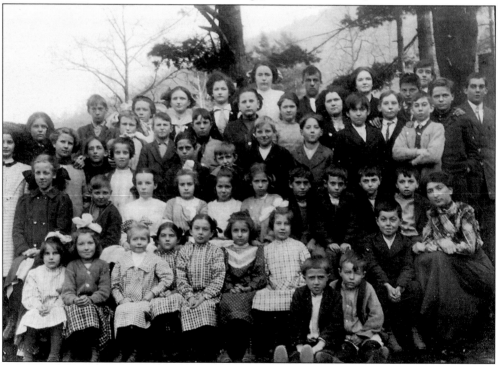

Because of the excessive number of children, classes were also held at the Methodist church beyond the Mountain House Hotel. A first year of high school was offered here also.

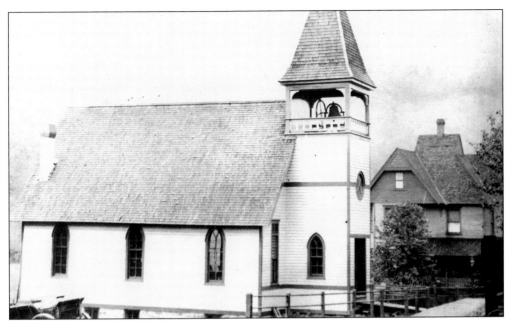

The Slate Run Baptist Church was erected around 1845–1846. It served the community until it was destroyed by fire in the 1930s. It was located in the north end of the village.

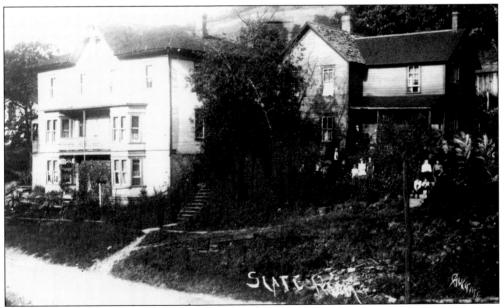

Pine Creek historian Spencer Kraybill identifies the three-story house on the left as the Custer House. Visible just to its left (north) is a window of the Slate Run Methodist Church. Among the people outside the second house in this Nelson Caulkins' photograph (around 1910) are members of the McConnell, Tomb, and Pope families, who apparently lived in both these houses.

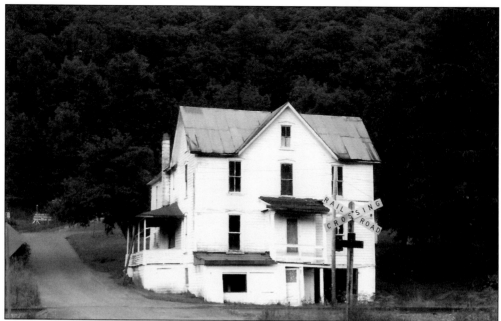

Charles Ivan Campbell (d. 1940) and his wife, Ruby Kennedy Campbell, ran a hotel in this house by the railroad tracks before the bridge over to the west side of Pine Creek. Charles was the son of Slate Run's Baptist minister William Robert Campbell and the grandson of Michael Campbell (1794–1881), a pioneer settler in the Cammal (a contraction of his name) area downstream.

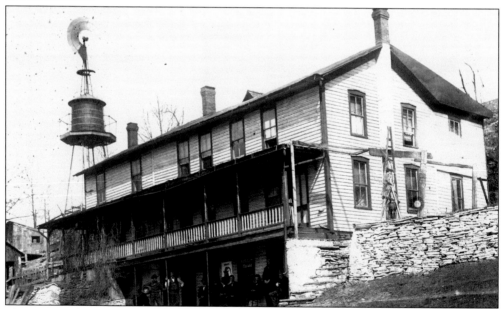

Slate Run's Mountain House Hotel was a popular rooming place during the great lumbering days. The windmill on its north side drove a pump, providing running water to the hotel. Note the Koch's sign in the one window, advertising Fred Koch's Dunkirk, New York, based brewery. It operated from 1911 to 1920, then was shut down by national prohibition, resuming production in 1933 until its closure in 1985.

Benjamin T. Wolf (1874–1951), the driver of this 1913 Buick, is parked in front of the Slate Run Mountain House Hotel. His wife, Della "Dolly" Belle Tomb (d. 1933), is behind him on the far left holding their daughter Evelyn F. Wolf Card. Benjamin was an area road supervisor for many years. He was also a talented coronet and trombone player.

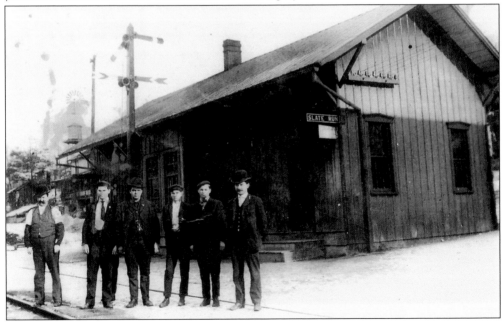

In front of the New York Central Railroad's Slate Run station are its six telegraphers, around 1910. From left to right are Charles H. Tomb (1869–1954), who also served as the station agent; unidentified; Ivan Campbell; and three unidentified. The tower and windmill visible behind the station were for water for the Mountain House Hotel.

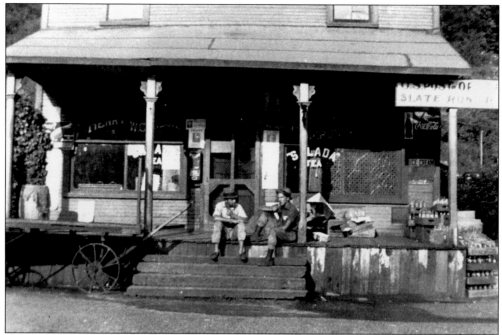

Two men in the early 1900s are enjoying a chat and their pipes on the steps outside Carson's store. Salada Tea signs on two of the windows and all the empty Coca Cola bottles on the right testify to the popularity of these drinks then. The New York Central Railroad tracks are just in front of the store.

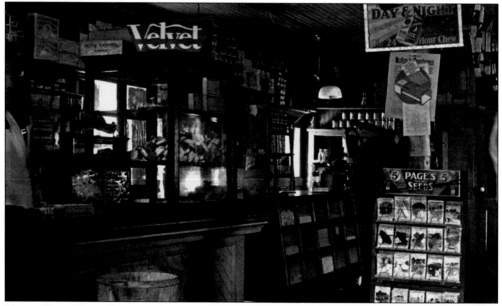

Henry Carson's gas-lit general store and post office in Slate Run offered, among many other early-20th-century desirables, Page's "tested" Seeds for 5¢ a packet; Day and Night tobacco, the "24 Hour Chew"; and Velvet pipe tobacco, "made from sun-ripened Kentucky burley." William and Anna Wolfe took over the business in 1946, moving it to its present location, renaming it Wolfe's, and running it for the next 30 years.

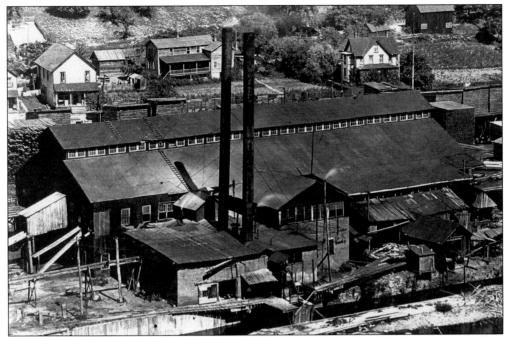

James B. Weed of Binghamton, New York, built this, his second Slate Run hemlock sawmill, in 1893, after his first had been destroyed by fire. Averaging a cutting output of 80,000 feet a day over the course of an entire year, his mill rated as "one of the 15 or so largest mills in Pennsylvania," according to historian Thomas Taber. Taber also calls it the "only significant industry" in the village then.

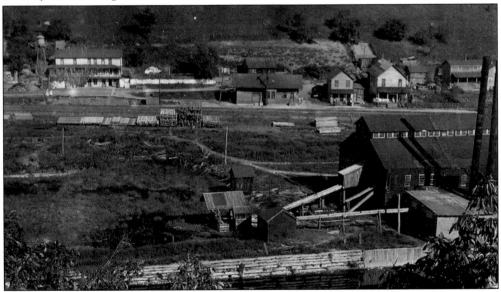

In this more northern and panoramic view, Weed's millpond and stacks of lumber can be seen. In the upper left is the Mountain House Hotel (with its water tank tower). The three buildings close together, and near to and facing the railroad tracks, from left to right are the New York Central Railroad train depot (note the shadow of its semaphore signaling blades on its roof), a restaurant, and Carson's general store and post office.

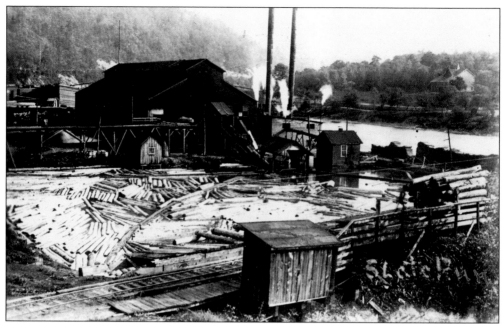

J. B. Weed and Company's Slate Run sawmill log pond, adjacent to Pine Creek, was the storage area for logs prior to processing. They were transported up the chute on the right side of the building to the log deck. The finished lumber was transported down, out of the sawmill on the rail trestle exiting the left side of the building. The tracks in the foreground are those of the Slate Run Railroad.

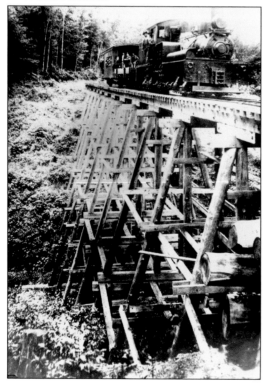

The engine crew of Shay locomotive No. 3 and those in the passenger car behind enjoy the view and smile for the camera. They are paused on the high trestle over Slate Run Stream about two miles from the village of Slate Run. It is more than a 60-foot drop to the run below.

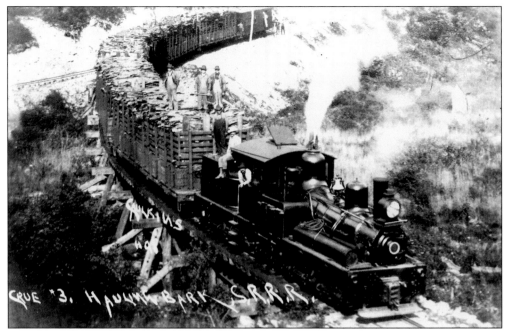

Shay No. 3 is bringing six gondola cars filled with hemlock bark down from the Black Forest to Slate Run. Beginning in 1881, James Weed eventually purchased a total of about 13,000 acres of very dense and dark (hence the name Black Forest), hemlock-filled virgin forestland. Shown stopping over one of the smaller trestles of the Slate Run Railroad, the train also has a caboose on its end for passengers.

The Slate Run Railroad's first bridge over Slate Run was located about a half mile above Pine Creek and the J. B. Weed and Company mill. Interestingly, as can be seen in the photograph, the tracks ran on top of the truss bridge, with the sides of the truss enclosed.

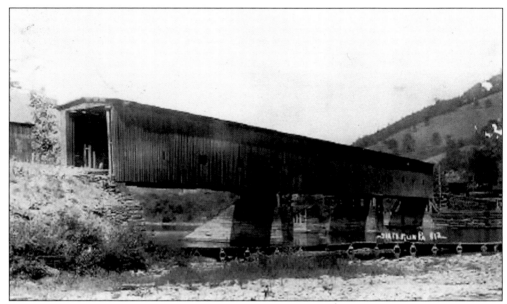

Just to the north of James Weed's sawmill, this covered bridge carried the Slate Run Railroad over Pine Creek on its way to Weed's great hemlock acreage in the Black Forest area about eight miles away. The bridge was one of just three logging railroad covered bridges in Pennsylvania (and, with its two piers, the longest); the others were at Cammal (seven miles below Slate Run) and at Hillsgrove (in adjacent Sullivan County).

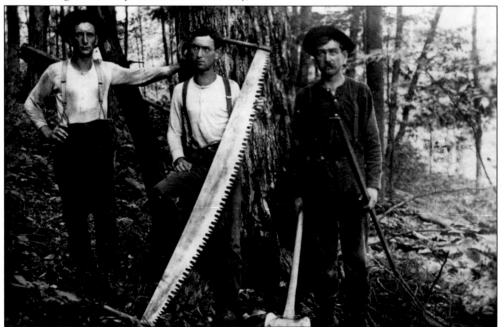

Three "wood hicks" who sawed down giant hemlocks for Weed's sawmill in Slate Run pause for a moment to be photographed. They are exhibiting the tools of their trade—a crosscut saw, a double-bitted axe, and an iron wedging pole. Although deemed less important than foremen, surveyors, or train crews, wood hicks earned a reputation for being the most hardworking, hard-playing, grungy, smelly, and most colorful men of the great lumber era.

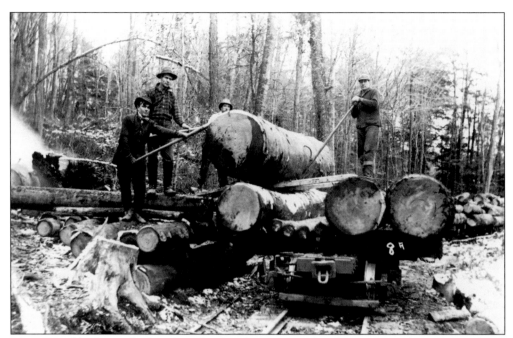

These wood hicks are loading logs for the Slate Run Railroad to carry to the J. B. Weed and Company sawmill in Slate Run. Not having a loader, they use their peaveys, or board ramps, and sheer muscle power to do the job.

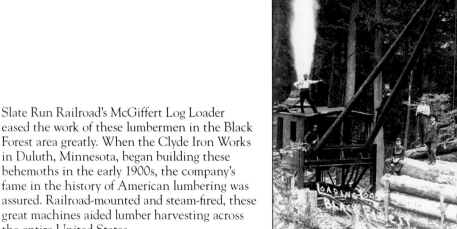

Slate Run Railroad's McGiffert Log Loader eased the work of these lumbermen in the Black Forest area greatly. When the Clyde Iron Works in Duluth, Minnesota, began building these behemoths in the early 1900s, the company's fame in the history of American lumbering was assured. Railroad-mounted and steam-fired, these great machines aided lumber harvesting across the entire United States.

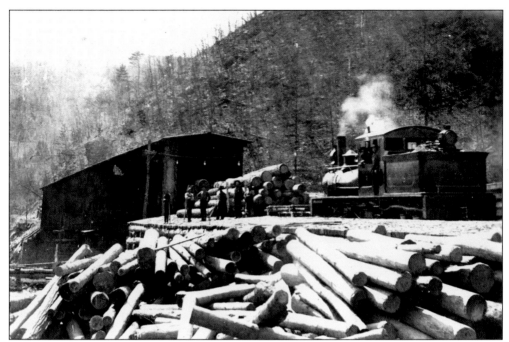

Shay locomotive No. 2 puffs away as logs are unloaded (two cars at a time) into the Weed and Company's millpond on the north side of the sawmill building and at the east end of the Slate Run Railroad's covered bridge across Pine Creek. The six men are working hard with their peaveys to maneuver the logs down into the pond.

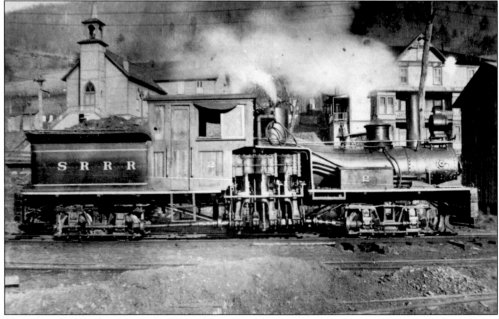

Slate Run Railroad's two-truck, 35-ton Shay No. 2 locomotive, built in 1890, was purchased new by James Weed. Behind the locomotive on the left is the Slate Run Methodist Church and on the right is the Custer House. After the engine's 20 years of service providing lumber for Weed's mill, it was sold in 1910 to the Central Lumber Company of Quentin, Mississippi.

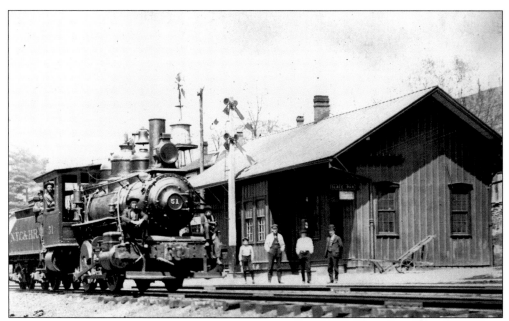

Locomotive No. 51, a 0-4-0 switch steam engine, was used by the Slate Run Railroad primarily to change trucks under bark cars. Here it pauses in front of the Slate Run depot. Also known as "yard goats" or "shifters," the 0-4-0s had no small leading or "pilot" wheel, four driven wheels, and no small trailing wheel (explaining the 0-4-0 designation).

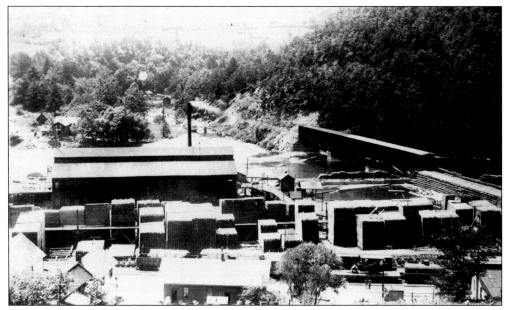

This view of the J. B. Weed and Company's sawmill complex shows the main building, the millpond to its right, the Slate Run Railroad covered bridge over Pine Creek, and the beginning of the railroad's course up Slate Run to the western timberlands.

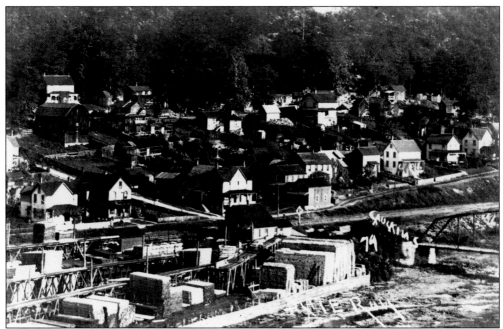

Lumber from the J. B. Weed and Company mill is stacked near the banks of Pine Creek just north of the vehicular truss bridge across to the west side. The large house in the center along the road leading straight from the bridge is the Campbell Hotel. Note how the houses along the railroad face the tracks. Route 893 (renamed 414 in 1955) would later cut through this southern end of the village, about midway between the hotel and the large barn.

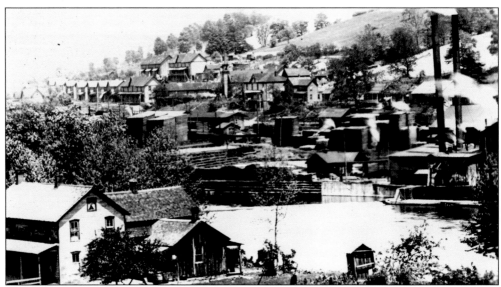

From the west side of Pine Creek, with what is possibly the Hotel Manor at the lower left, can be seen the northern section of the J. B. Weed and Company sawmill. The New York Central Railroad runs in front of the string of houses above the mill and its lumberyards. Note the row houses to the left, then the steepled Methodist church further to the right, followed immediately by the Custer boarding house.

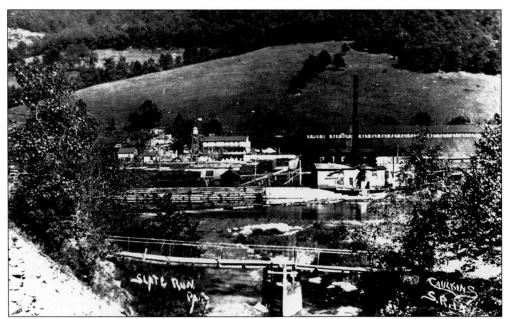

A pedestrian bridge on the west side of Pine Creek provided passage over Slate Run near its mouth. The bridge connected the bed of the Slate Run Railroad (left) to the "Hotel Manor" area. Across Pine Creek are the Mountain House Hotel (with its windmill) and the J. B. Weed and Company lumber mill.

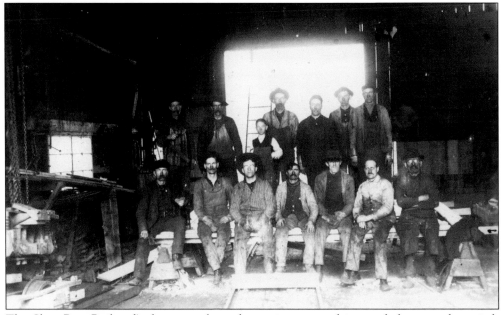

The Slate Run Railroad's shop crew kept the equipment working, and they ran the switch engine that changed the cars between the standard and narrow gauge tracks. They are, from left to right, (first row) Ike Bull (foreman), John Tomb (shop hand), Harry Halford (No. 51's engineer), Video Vadero (locomotive "hostler" or servicer), Paul Stevens, Frederick Wessell, and George Reibe (blacksmith); (second row) Ralph Kilborne, unidentified, Mel Dyer (boy), George Carleton, C. H. Stevens, William Graham, and unidentified.

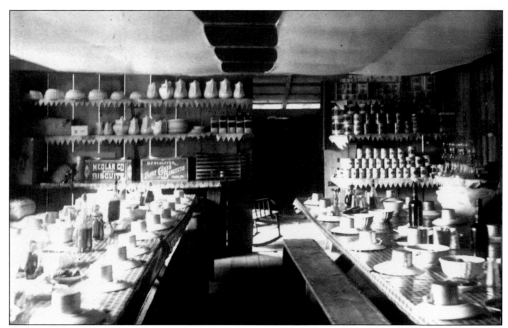

The dining room in a lumber camp in the mountains west of Slate Run is ready for the hungry wood hicks. Cheesecloth on the ceiling catches dirt falling down from upstairs. Note the two biscuit boxes on the shelves, labeled "Medlar Company Biscuits" (based in Philadelphia) and "D. F. Stauffer Fancy Cakes & Biscuits" (out of York, Pennsylvania, and the producer of the original "animal crackers" since 1871). The rocking chair is in the after-dinner lounge room.

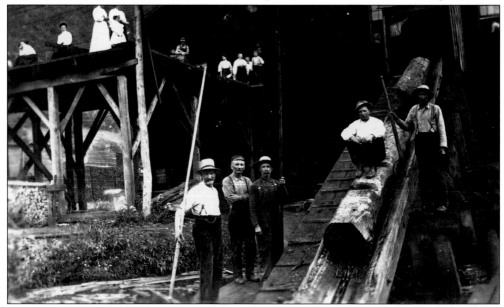

When the last log rode up the trough from the millpond into J. B. Weed and Company's sawmill on July 28, 1910, Slate Run women, who were dressed in finery, and some children joined workers to witness the event. The mill's contract with the Pennsylvania Joint Land and Lumber Company to harvest hemlocks in several thousand acres of southwest Tioga County was completed. Very soon afterwards, the mill was razed and the Slate Run Railroad dismantled.

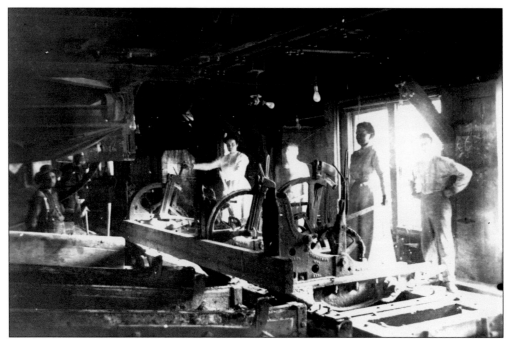

Making the final cut on the last log to go through James Weed's mill were Allie Harris (left), wife of the superintendent, and Mary Carleton. Frank McConnell, sawyer, stands at the left. George McConnell (left) and Jim Hawk, behind the women, had been the dogger (mill worker who positions and secures the logs on the saw carriage) and setter (one who adjusts the width of the cut), respectively, until the final log.

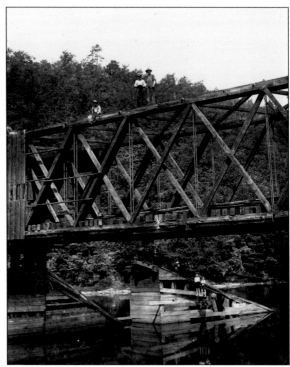

The Slate Run Railroad's covered bridge over Pine Creek is shown being dismantled in 1911. The J. B. Weed and Company sawmill, which the railroad served, had ceased operations the year before, after almost a quarter of a century of hemlock log cutting.

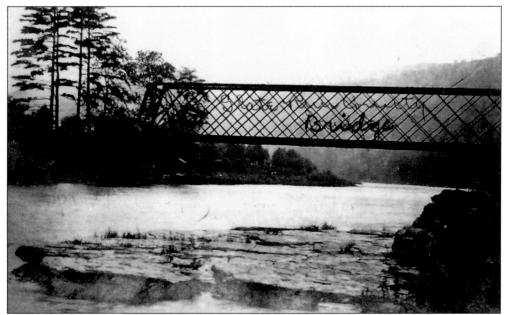

This lattice truss, wrought-iron, one-lane bridge over Pine Creek just north of Slate Run was built in 1890 by the Berlin Iron Bridge Company of Connecticut, after the disastrous 1889 flood. The photograph was taken not too many years afterwards. Consisting of a single span, the bridge has a length of just over 202 feet. It was placed into the National Register of Historic Places in 1988.

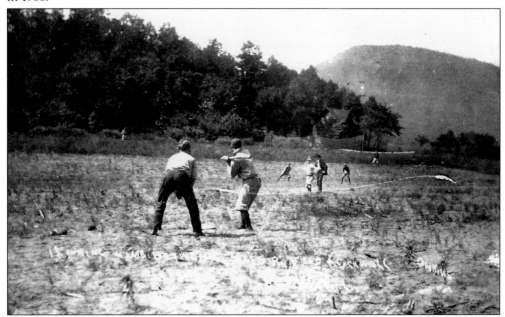

On this photograph of an early 20th century amateur baseball game played at Slate Run, photographer Nelson Caulkins wrote that Slate Run defeated Blackwell 7-6 in 13 innings. Pine Creek Valley villages took pride in their teams, with the players wearing uniforms whose lettering identified their communities. The inter-village baseball heydays lasted until World War II, after which Little League eventually became predominant.

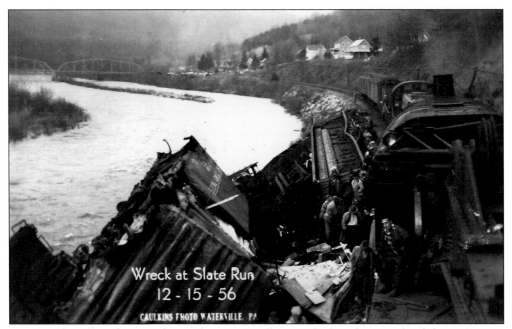

Pine Creek Valley photographer Nelson A. Caulkins took this photograph of the 1956 train wreck when he was 82 years old. It occurred just south of Slate Run. It was reported that locals ventured into the cold water to get watermelons and potatoes from the cars that spilled them into the creek. The truss bridge across to the west side of Pine Creek is visible in the distance.

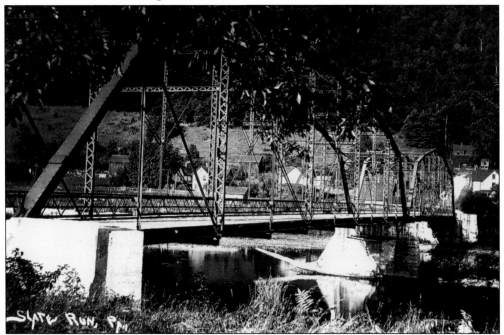

The Slate Run steel truss bridge from the east side of Pine Creek over to the west side (the Hotel Manor and Baptist cemetery areas) was constructed in 1902 by the Nelson and Buchanan Company of Chambersburg and Pittsburgh. It was razed and then replaced by a concrete span in 1986–1987.

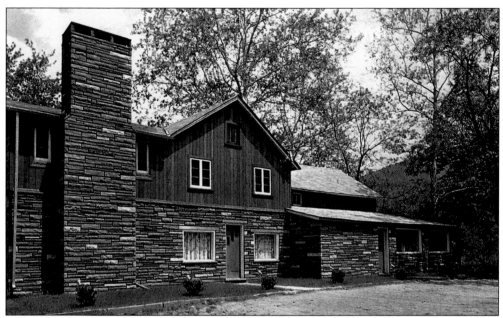

In the early 1950s, newly remodeled Hotel Manor was owned by Edward Haines, a man who possessed many properties in Slate Run, Cedar Run, and Blackwell in those days. Once called Manor Hunt, the longtime popular hotel and drinking and eating establishment (even during the great lumbering days) was built at the location of pioneer Jacob Tomb's old 1790s homestead, at the mouth of Slate Run. It has remained in business into the 21st century.

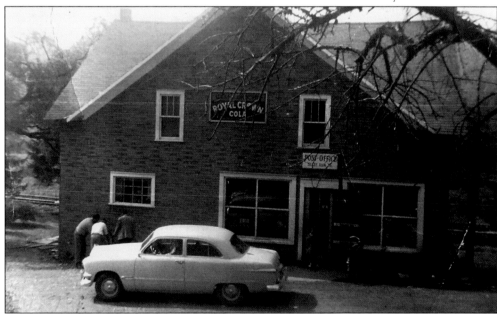

After coming home from World War II, William Wolfe took out a loan and built Wolfe's General Store and Slate Run Tackle Shop. Constructed on the grounds behind where the old railroad depot had been, it became the village's replacement store for Henry Carson's old establishment. Wolfe and his wife, Anna, ran the store from 1946 to 1976, selling it then to today's owners, Thomas and Debra Finkbiner. The photograph is from the 1950s.

Seven

CEDAR RUN
AND LEETONIA

The village of Cedar Run, about five miles north of Slate Run, also prospered during the lumber era, despite its greater isolation and that no logging railroads were ever built up into the mountains.

Known sawmills in the first half of the 19th century included one constructed by a Jacob Warren in 1819 above the present-day village and another erected by John Bowen in 1847 just below Cedar Run stream. By the 1890s, John S. Tomb and Son's steam sawmill was operating across from the mouth of Cedar Run, while Joseph Wood and Joseph Childs ran another one at the mouth of Jacob's Run just below the village.

A Baptist church was built around 1850, about a mile below Cedar Run on the west side of the creek; worship services are still regularly held there today. A Methodist Episcopal church was erected in 1897 down in the village itself, but it closed sometime before 1940, the building left standing and privately owned to this day.

Cedar Run became a postal village in 1853 (the post office not closing until 1993), with Lucius Truman appointed its first postmaster. At that time the village also had one hotel, one school and one store.

In 1890, Cedar Run's prosperity was at its greatest. A Lycoming County historian at that time, John Meginness, recorded that 885 people lived there then.

The Cedar Run Inn opened around 1891 and the Cedar Run General Store about 1895. Both establishments remain in business today.

About seven miles up Cedar Run, northwest of the village, was a lumbering community named Leetonia, with a tannery and a small sawmill. A daily stage ran between the villages beginning in the 1880s, carrying both mail and passengers. Leetonia's output of lumber, bark, and leather was brought by wagon down to Cedar Run until the Leetonia Railroad from Tiadaghton (about 10 miles above Cedar Run) was completed in 1899, linking Leetonia to the New York Central Railroad mainline at Tiadaghton.

In the 20th century and into the 21st century, Cedar Run has been a popular destination for trout fishermen, especially those interested in fly-fishing for native wild brown and brook trout. A very successful YMCA summer camp for both boys and girls called Camp Cedar Pines ran from 1920 to 1946. Today a large, privately owned campground is at the north end of the village.

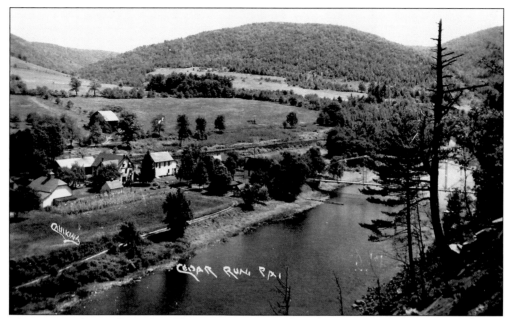

The view to the southeast from the mountaintop yields the village of Cedar Run, early in the 20th century. From left to right, down in the village, are the Cedar Run Inn's barn, the train station, the Cedar Run Inn (established in 1891), the Cedar Run General Store (established in 1895), the Methodist church, and the iron truss bridge across Pine Creek to today's Route 414. The dirt road meandering up the hillside is the Jacob's Run (or Beulah Land) road.

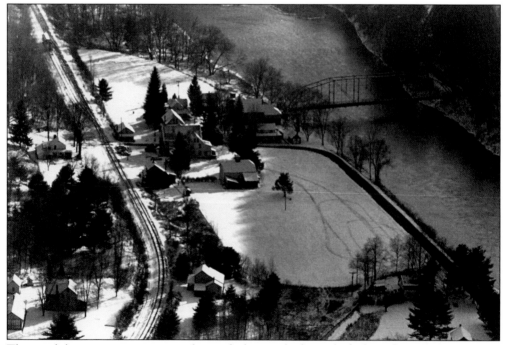

This much later panoramic view to the south shows vehicles parked where the train station once stood next to the Cedar Run Inn. The double railroad tracks (main line and siding) begin at the south side of the village

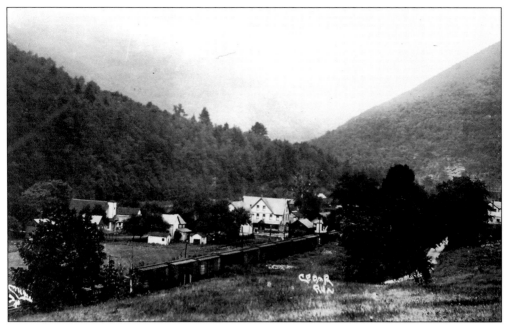

Sometime during the early decades of the 1900s, this train stopped at the New York Central Railroad station, which is located directly to the right of the three-story Cedar Run Inn. The Methodist church is on the left, with the mountains to the north.

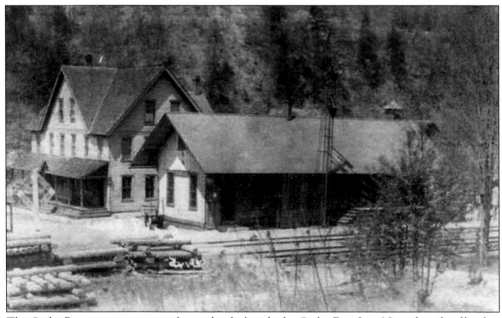

The Cedar Run train station was located right beside the Cedar Run Inn. Note the pile of lumber beside the New York Central Railroad tracks in this very early 20th-century photograph.

This January 5, 1928, photograph shows the railroad water tank near Jacob's Run just south of Cedar Run. Usually built 10–12 feet above the tops of the rails, the large, wooden tubs were placed upon strong frameworks, supported by heavy pillars. The Cedar Run discharge pipe is in the "up" position on the left, lowered and swung over the water hole in the train's tender tank to provide the water needed by the steam engines.

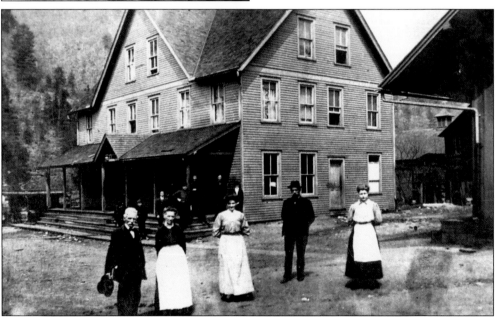

In 1902, the Cedar Run Inn was owned by George and Teressa Extrom Gamble. Seen here are, from left to right, William and Elizabeth Wrean Gamble (George's parents), then Teressa, followed by Ida Extrom Monks (Teressa's sister) and her husband, Elzner Monks. Ida and Teressa arrived in America from Sweden. The Monks lived on a farm up in the mountains above the village of Cedar Run, in an area known as Beulah Land.

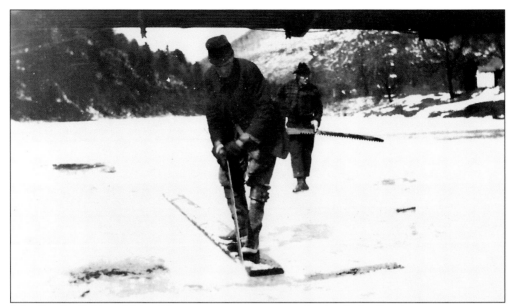

John Snyder (left) and John Champayne are cutting ice for the Cedar Run Inn many years ago. It would be packed in sawdust and stored in the icehouse.

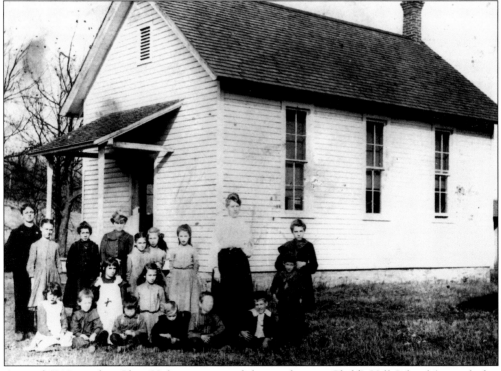

Around 1910, teacher Clara Holmes poses with her students at Child's Hill School (named after the prosperous Mr. Childs, who had owned the land), also known as the Beulah Land School. It served the lumbering community that developed in the mountains southeast of Cedar Run. It was also used as a Sunday school. In 1918, people with cars were first employed to drive children to the school.

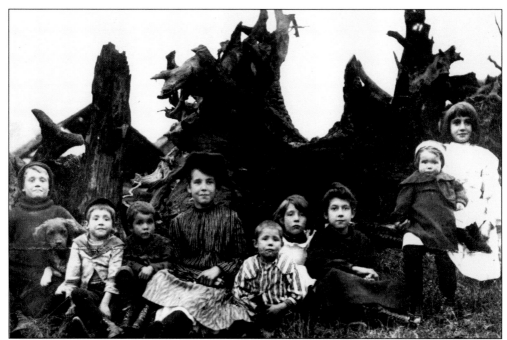

Nine children and a dog pose in front of a pine stump fence that was typical of the Beulah Land farms in the very early 20th century. Now an area only of hunting camps, Beulah Land was a lumbering community in the late 1800s, before its residents turned to farming in the first half of the 1900s. It is about five miles up in the mountains southeast of Cedar Run, at the head of Jacob's, Mill, and Elk Runs.

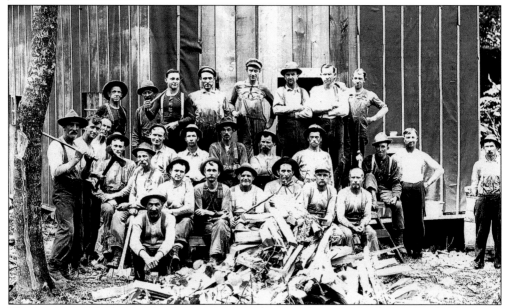

These are wood hicks at a lumber camp somewhere in the Pine Creek area, probably in the Black Forest to the west. Third from the left in the back row is Gus Bennett (not wearing a hat). Bennett (1886–1967), born and raised in Slate Run, lived in Leetonia and was also a hunter, a guide, and then a worker on the Alaskan Highway later in life in 1942.

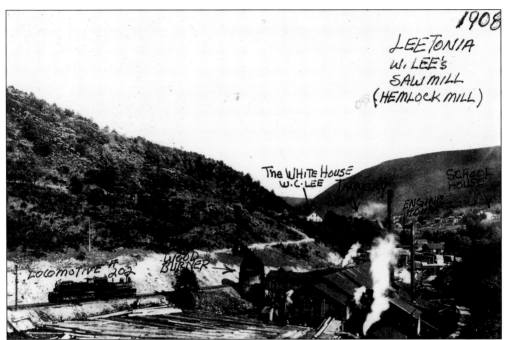

In 1879, W. Creighton Lee of New York State erected a tannery seven miles up Cedar Run from the village of Cedar Run, thus beginning the community named after him—Leetonia. In 1893, a small hemlock sawmill was added. Then in 1899, the Leetonia Railroad was incorporated, providing a connection from Leetonia to the New York Central Railroad line through Pine Creek Valley, ending 20 years of isolation for Leetonia.

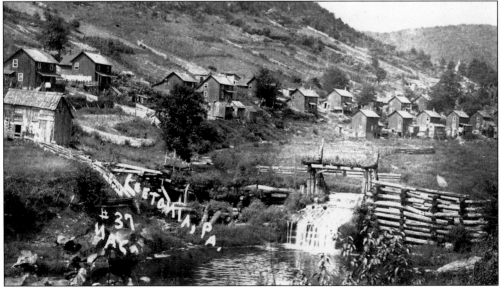

In 1903, the tannery, the sawmill, and the land in Leetonia became the property of the newly-formed Central Pennsylvania Lumber Company. The company homes, shown in this 1908 photograph, originally painted red but never renewed, were located in the lower, southern section of town. With the closing of the hemlock mill in 1921 and then the tannery, most families left Leetonia.

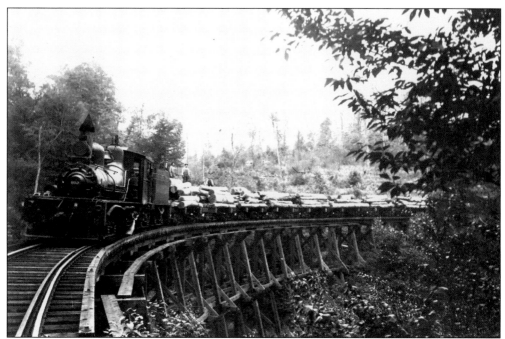

Leetonia Railway's Shay No. 202 engine is pulling a multi-car load of logs across the Little Slate Run trestle, just north of Ice Break Run, about two miles south of Four Mile Run, and a mile west of Pine Creek. In 1903, the rails were extended another two miles to Bear Run, only three miles below Ansonia. In the 1890s and the first decade of the 1900s, lumber camps sprouted in these mountainous regions.

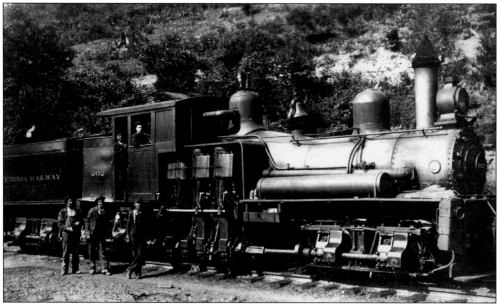

A three-truck, 70-ton Shay No. 4 engine was purchased new in 1904 by the Leetonia Railway and then renumbered as 202. In 1921, the engine was sold to the Central Pennsylvania Lumber Company (which, back in 1903, had bought the Union Tanning Company's two Leetonia saw mills) and renumbered again to 73.

This 1925-era hunting cabin was located in the Algerine area several miles up Gamble Run west of the village of Cedar Run. A synonym for pirate, the term algerine was used during the great lumbering days to refer to those men who stole logs stranded along the waterways. The remote Algerine swamplands and wild areas had growths of black spruce, white and pitch pines, balsam fir, and hemlocks.

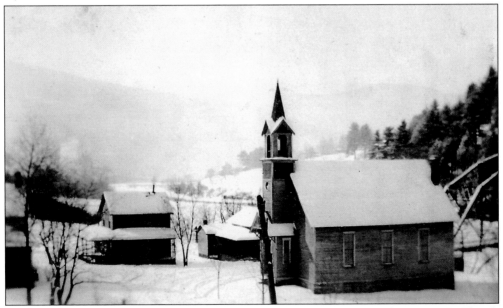

This is the Methodist Episcopal church in Cedar Run during the winter of 1924. "M. E. Church 1897" was etched into the front of the building above the entrance. Although no longer a house of worship, it has remained standing and in use as a summer cottage into the 21st century. The truss bridge behind and to the right of the church spans Pine Creek.

Helen Nivison (1907–1985) enjoys a moment in her childhood, perched on the bridge over Pine Creek into the village of Cedar Run. Her parents, Charles and Cora Hilborn Nivison, owned the Cedar Run Inn at that time. Helen later became a schoolteacher in Cedar Run in 1926 and never married.

Anna Esther Paucke LaBarr (1907–2006) was the manager and chief cook of the Cedar Run Inn, working there from 1923–1939. She is seated on the front steps of the Cedar Run Inn sometime in the 1920s. In 1939, she married Russell LaBarr (who had been a telegrapher at the Cedar Run station), after which they moved to New York State, where she raised two sons and a daughter. Her parents, John and Mary Schmitka Paucke, were immigrants from Poland.

A steel truss bridge crossed over Cedar Run stream where it empties into Pine Creek at the north end of the village of Cedar Run. Clearly visible on professional photographer Nelson Caulkins's c. 1930 picture postcard are his descriptive words, "highest bridge in Lycoming County." Most likely, that is his Ford parked on the north side of the bridge.

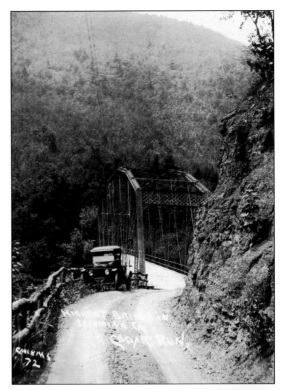

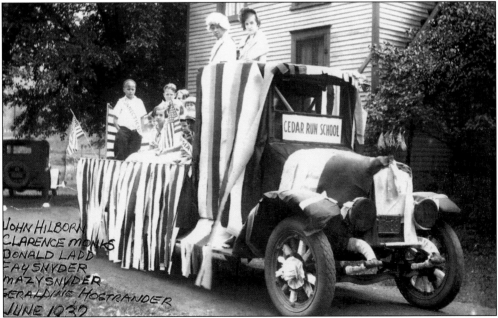

The Cedar Run school children created a very patriotic float back on Flag Day, June 14, 1932. John Wrean Hilborn (1921–2005) is standing on the left, wearing the Connecticut banner. After serving in World War II, he continued a career with Corning Glass, first at Wellsboro, Pennsylvania, and then in Albion, Michigan. He was an avid deer and bear hunter, returning when he could to the woodlands around Cedar Run.

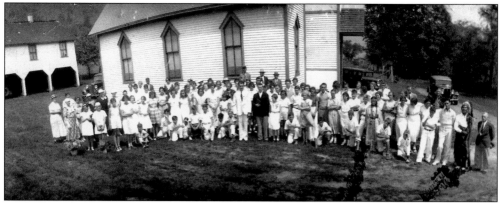

This gathering at the First Baptist Church of Cedar Run occurred in the 1930s. The boys and girls are campers at nearby Camp Cedar Pines. Among the adults are the camp director, Clyde Baltzer (in the front row wearing the white suit), and, standing by his side, the camp minister. The two Native Americans at the right front, identified (with a pen that ran) as "Sankapama" and "Judson Toma," taught arts and crafts at the camp for years.

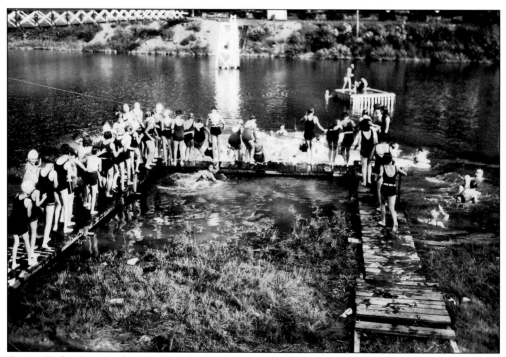

Camp Cedar Pines, advertised as "A Real Camp for Real Boys and Girls," ran from 1920 to 1946 at a 45-acre location along the western side of Pine Creek just south of Cedar Run. Under director Clyde E. Baltzer, the summer camp was owned and operated by the New York Central Railroad and the Jersey Shore YMCA. Note the footbridge (built in 1925) over the creek to the train.

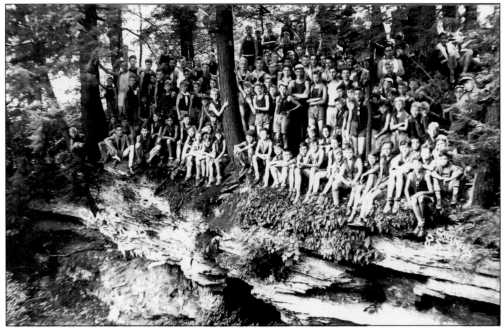

Camp Cedar Pines had a separate multi-week session for boys, another for the girls. This group of lads from a summer long past is shown posing among the trees along what is most likely Gamble Run just west of the main camp and current Route 414. By the end of Cedar Pines's existence as a camp "for boys and girls of good character," campers had come from 13 states and one foreign country—Scotland.

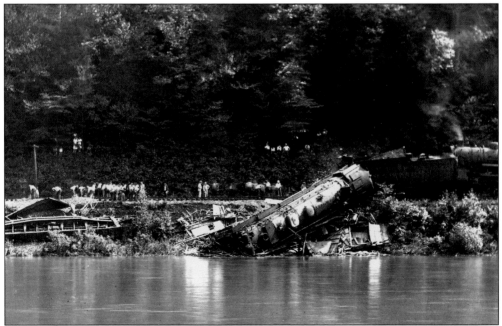

On August 28, 1933, a New York Central Railroad train wreck occurred across from Camp Cedar Pines just south of the village of Cedar Run. Quite a few of the villagers walked down the tracks to view the wreckage, with an engine on its side at the edge of Pine Creek.

The Cedar Run School, shown here in 1936, educated area children until 1947. It was located on the hillside near the entrance off present-day Route 414 down into the village. Twentieth-century teachers included Helen Nivison, Jeannette Spong, and W. L. Lloyd.

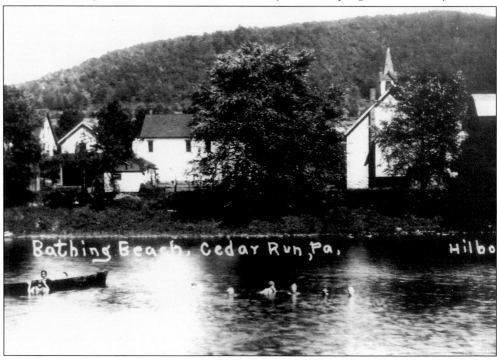

Village children are cooling off in the waters of Pine Creek many years ago. The Cedar Run Inn, the general store, and the Methodist church are visible behind them, from left to right.

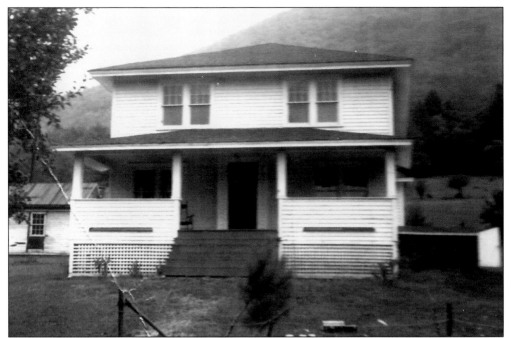

From 1937, when they were married, John and Mary Eliza Tomb Paucke lived in this house (photograph from the 1940s) near the Cedar Run Baptist Church. John's father, John Paucke Sr., had arrived in the area from Poland in the first decade of the 1900s, obtaining a job at the tannery in Leetonia. Mary, a third great granddaughter of pioneer Jacob Tomb, has continued to live at the home after her husband died in 2001.

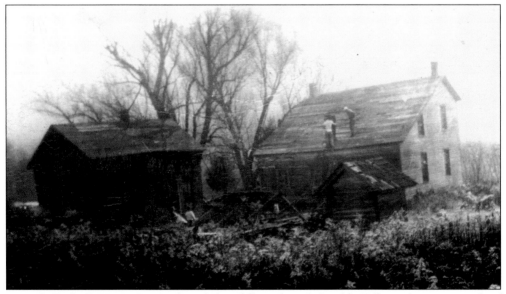

In 1947, Earle F. Layser Sr. purchased the "falling down" Gamble-Hilborn farm just south of Cedar Run off Route 414, with the intent of turning it into a turkey farm. Layser and John Paucke Sr. are pictured working on the roof that year. The farmstead had belonged to the Hilborns since 1900, the Gambles before that back to the 1860s. Both these families had been among the early settlers on Pine Creek.

Elsie and Earle Layser, the Canyon Turkey Farm proprietors, are inside a turkey pen working with young poults in 1954. They operated the farm for 30 years (1950–1980), meeting a demand for their domestic bronze turkeys (rare today, and now considered a heritage or heirloom breed) that grew from about 200 the first year to about 3,000 a decade later.

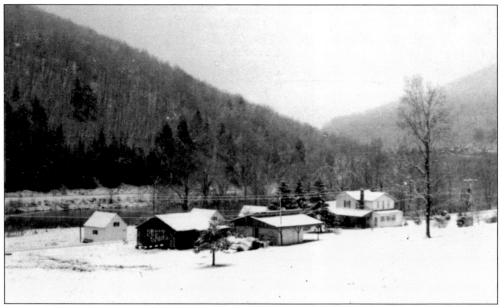

The Canyon Turkey Farm in the winter of 1961 consisted of a restored pioneer residence, four brooder houses, a three-bay equipment and supplies shed, three large corn cribs, a carport, a pole barn, a shop, and a dressing plant building (not all shown in the photograph). In addition to hatching, raising, dressing, and locally marketing their prized turkeys, the Laysers also farmed the land, growing corn and oats for turkey feed.

John Burton Hilborn (1880–1961) is enjoying a break inside the Cedar Run General Store in the 1950s. In addition to running the store for many years, Hilborn worked as a telegrapher for the New York Central Railroad. His sister and her husband, Jennie and Fred Wilson, owned the Cedar Run Inn.

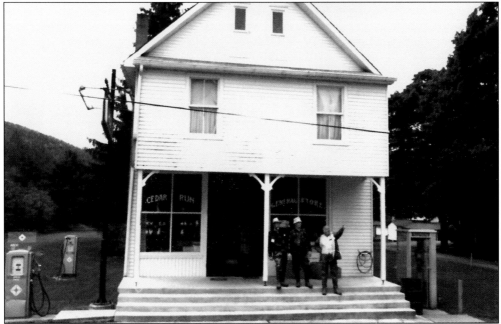

Out in front of the Cedar Run General Store, three trout fishermen (one pointing, perhaps, to a bald eagle soaring overhead) are enjoying a day, most likely, in the late 1960s. Note the old Atlantic Richfield Company (ARCO) gasoline pump beside the store, a fuel brand that began in Pennsylvania in 1966.

The Brown Township Volunteer Fire Company was formed in 1978 with Albin Wagenseller as fire chief. This 1983 photograph was taken in front of the newly constructed firehouse (before that, their equipment and truck had been stored in the barn of the Cedar Run Inn, at a rental fee of $1 a day), with members, from left to right, Clarence Iceman, Charles Wolfe, Herbert Stratton, Howard Bradshaw, Alfred Slater, and John Campbell.

In February 1989, the last train, led by Pennsylvania Conrail's Electro-Motive Diesel (EMD) engine No. 8219, went through Cedar Run, the tracks pulled out shortly afterwards. Thus ended just over 105 years of train service through Pine Creek Valley, the tracks having been completed back in May 1883.

Eight

BLACKWELL

Five miles above Cedar Run, the village of Blackwell is at the juncture of Pine and Babb Creeks. Named after the pioneer family that arrived in the area back in 1811, this very small village is still home to a few descendants of Enoch Blackwell Sr.

Blackwell made a living lumbering, as did many of his descendants. A grandson, also named Enoch Blackwell, was the village's first postmaster, from 1862 to 1886. The post office (which closed in the late 1930s) was actually named Lloyd, in honor of Thomas Lloyd, who had been brought as a child by the Blackwells from England to America. Lloyd prospered at Blackwell, marrying Elizabeth Campbell, and raising 16 children.

A sawmill, gristmill, and general store were all built in 1825. The first teacher, Samuel Harrison, instructed the community's children from 1832 in a school building erected on Babb Creek about a mile above Blackwell. It is used today as a hunting cabin named, appropriately, Blackwell Schoolhouse.

To meet the community's spiritual needs, a Methodist Episcopal congregation was organized around 1859, with meetings held in the schoolhouse until 1892, when a church edifice was finally constructed in the village. It still stands today, maintained by the village as a historical property, and used once or twice a year for a community service and dinner.

Hotels catered to early lumbermen, travelers, visitors (a daily stage ran between Blackwell and Morris, five miles up Babb Creek), and eventually railroaders (beginning in the mid-1880s). William Blackwell (son of pioneer Enoch) ran the first hotel from about 1825 until his death in 1859. The hotel known as the Gillespie House opened in 1882; it remains open today, known now as the Blackwell Hotel.

Although the present-day village of Blackwell has no other businesses, progress has occurred. A new concrete bridge replaced the old Route 414 steel truss bridge over Pine Creek in 1993; the road between Blackwell and Cedar Run was finally paved in 2001; and the very popular Pine Creek rail trail, with a modern access parking area in the village, leads from Blackwell up into what has been called Pennsylvania's "Little Grand Canyon."

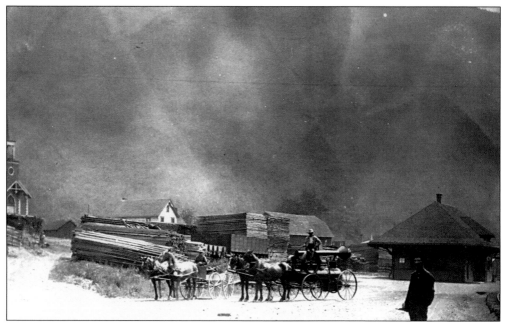

Four important aspects of Blackwell Village life appear in this very early 1900s photograph. The Methodist Episcopal church was erected in 1892. A daily stage carried mail and passengers between Blackwell and Morris. The lumber piles testify to the importance of the logging and milling industries. And the train station and the Fall Brook Railroad (purchased by the New York Central Railroad in 1899) linked Blackwell to the wider world.

From high on the West Rim road, the village of Blackwell can be seen below and to the south in this early 20th-century photograph by Nelson Caulkins. Visible are the Methodist Episcopal church with its steeple, the New York Central Railroad tracks with the Blackwell station, the Blackwell Hotel (large, light-colored building), and Gillespie Mountain beyond. Pine Creek is hidden among the trees down from the road.

In 1881–1882, William P. Blackwell built his hotel in Blackwell. From left to right (around 1910) are (first row) George and William Duffy, and Delmer, Emory, Arthur, and Harry Blackwell; (second row) Susan Smith, Nell Briggs, Mildred Atherton, William Smith, Hazel Clark, unidentified, Ethel Brinthaupt, unidentified, Louise Campbell, unidentified, Jeanette Spong, Spong's unidentified nephew, Joanna Desmond, Desmond's unidentified sister, Christine Duffy, and Jenny and John Gillespie.

Blackwell's Citizens Cornet Band (around 1910) was composed of 13 players. Seen here are, from left to right, (first row) Charles Hostrander (drum), Enoch Blackwell (snare drum), Herman Campbell (cornet), Richard Blackwell (cornet), Janette Campbell (cornet), Nila Raemore (cornet), and Louise Campbell (trombone); (second row) Leo Fish (alto), Harry Compton (French horn), Wallace Raemore (tenor), Harry Blackwell (bass), Willis Campbell (baritone), and John Keller (leader).

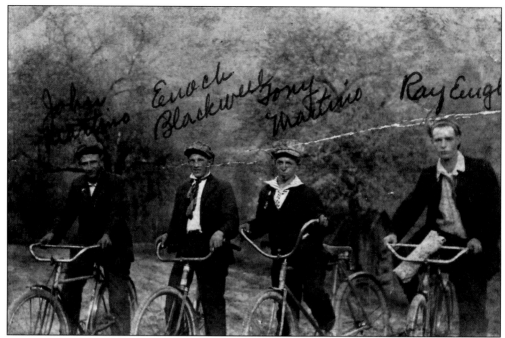

Four friends are out bicycling around Blackwell one fine day in around 1915. The boy on the right, Raymond Fayette English, was a great-great grandson of James English (1744–1823), an aide to Gen. George Washington during the Revolutionary War and one of the noted hunters and trappers of his time in Pine Creek Valley.

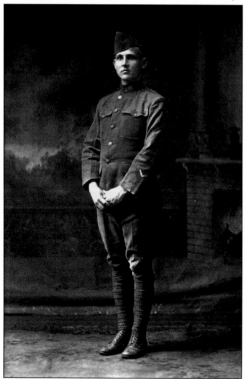

Arnold Blackwell (1893–1967) was the great-great grandson of Enoch Blackwell, who came from England and in 1805, was the first Blackwell to settle in the area. Arnold was a World War I veteran, serving in the Army Signal Corps, and then a rural mail carrier in Blackwell's Morris Township after the war, delivering the mail in a horse and buggy.

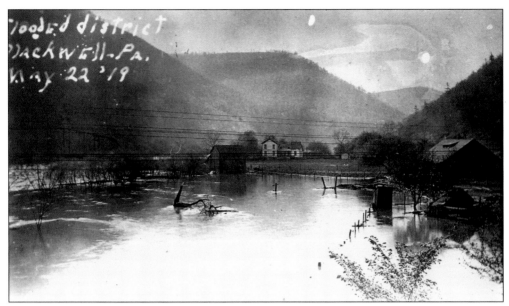

Late spring floodwaters inundated the southern section of Blackwell in 1919. The truss bridge across Pine Creek is on the left, the pioneer Blackwell homestead (built probably in the 1860s) in the center. Pine Creek Gorge begins between Cedar Mountain (left) and Fork Hill, continuing north for 17 miles to Ansonia.

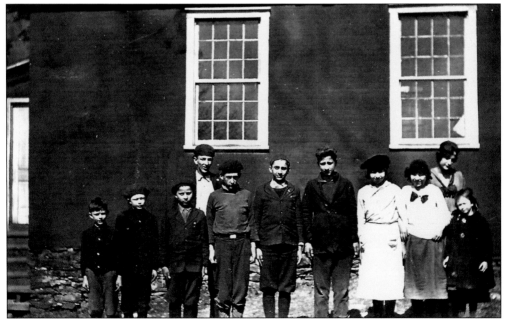

Blackwell Village school children stand in front of their school in the 1920s with their teacher, Jeannette Spong, in back on the right. The school was located just above the bridge over Babb Creek, on the east side of the road toward Morris. The building still stands as a hunting camp into the 21st century, appropriately named the Blackwell Schoolhouse camp.

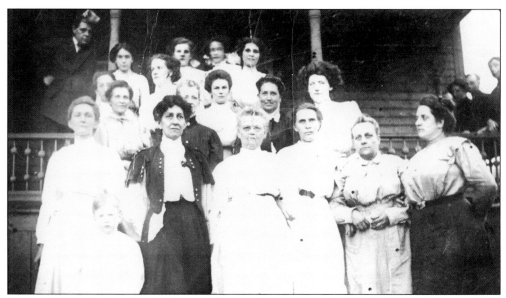

Blackwell's Methodist Church Ladies Aide members pose at the Blackwell Hotel around 1920. Preacher William Allen is above, leaning against the post, and Bernard Callahan is the boy in the front row. The women have been identified as, from left to right, (first row) Flora Lewis, Mary Blackwell, Addie Blackwell, Cila Blackwell, Mrs. Adelbert Warrener, and Grace Blackwell; (second row) Evie Campbell, Jane Blackwell, Eva Morrison, and Mrs. Elias Whithey; (third row) Mamie Custaborder, Ada Fish, and Ethel Fish; (fourth row) Maude Callahan, Ruth Smith, Jeannette Spong, and Nora Smith.

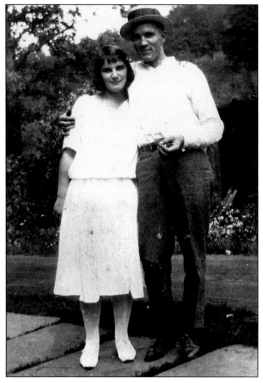

Gladys Hilborn and Enoch Blackwell married and had six sons. Gladys was a descendant of both the Hilborn and the Tomb pioneers of Pine Creek Valley. Enoch was a great-great-grandson of the pioneer Enoch Blackwell. Working down by the Trout Run Narrows as a night watchman for the railroad, Enoch was killed one night patrolling the tracks, when something protruding from one of the cars of a passing train hit him in the head.

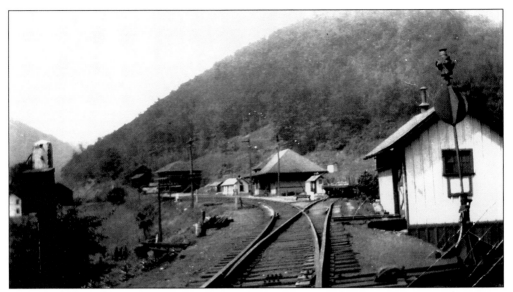

New York Central Railroad's Blackwell Station was still in operation in the 1930s. The storage shed for handcars is in the foreground. The Barton House (originally built to house railroad worker crews in the late 19th century) is behind the station at the north end of the village; it has remained standing into the 21st century.

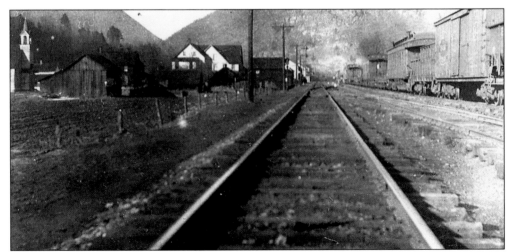

A train rolls through Blackwell sometime in the 1930s or 1940s. The Methodist Episcopal church on the left was built on land donated by the Lattimer family. The large house with the white siding is the Blackwell Hotel.

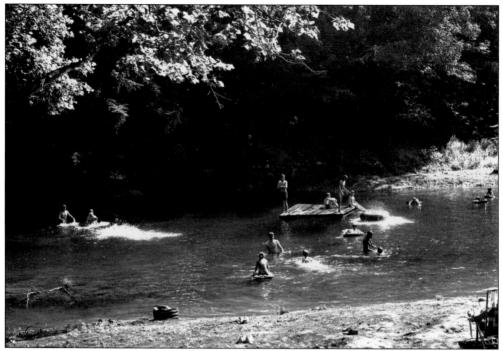

These children from a summer of long ago are cavorting in Babb Creek's Sucker Hole. The creek empties into Pine Creek not far below this favorite swimming hole. In the wintertime, residents of Blackwell would cut ice out here for their icehouses.

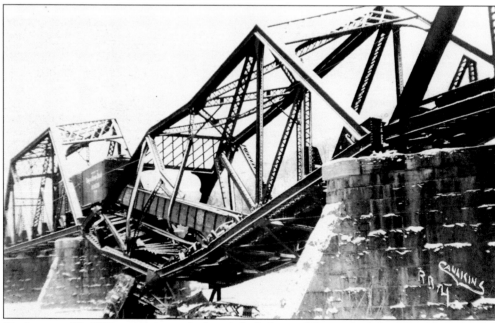

On January 30, 1951, a train wreck demolished the middle span of the New York Central Railroad's three-span bridge over Pine Creek at Blackwell. In passing over the bridge, a crane that the train had been carrying struck the bridge's structure, resulting in the crane's plunging into the creek. Note the Seaboard "Orange Blossom Special" boxcar.

In the winter of 1970, an ice flood left Donald and Martha Blackwell's house (built about the 1860s and owned by Blackwell descendants since then) surrounded by boulder-sized chunks of the frozen Pine Creek water. The Route 414 bridge over the creek just below their house and the railroad bridge below it were also jammed up, giving the whole area its arctic wilderness appearance.

This was the picturesque New York Central Railroad trestle over Route 414 in Blackwell. It was taken out when the steel truss road bridge over Pine Creek (visible through the trestle underpass) was replaced in 1993 by a concrete span immediately to its south.

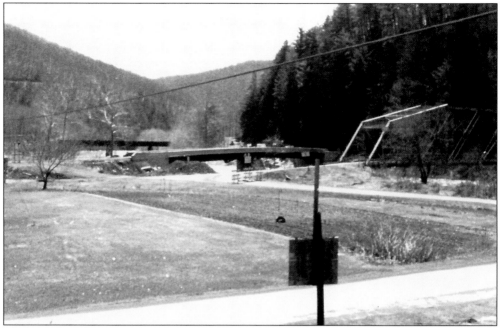

Blackwell had three bridges across Pine Creek at one point in 1992. The steel truss is about to be razed, the middle concrete span is its replacement, and the one in the distance is the old New York Central Railroad crossing (the tracks had been removed in 1989 after Conrail abandoned the line the year before, and the bridge was left for the rail trail).

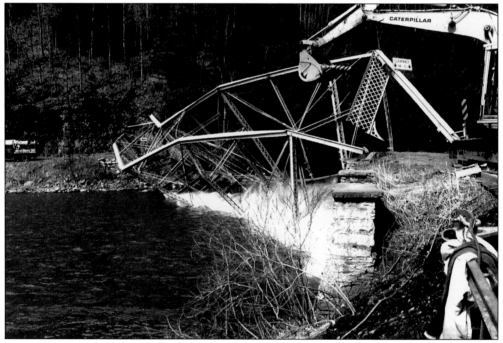

The Route 414 steel truss bridge leading into the village of Blackwell from the south splashes into Pine Creek in October 1992. It was razed to be replaced by a concrete span placed just to the south of the old bridge.

BIBLIOGRAPHY

Collins, Emerson. Genealogical and Personal *History of Lycoming County Pennsylvania*. St. Louis: Lewis Publishing Company, 1906.

Kraybill, Spencer L. *Pennsylvania's Pine Creek Valley and Pioneer Families*. Baltimore: Gateway Press, 1991.

Lloyd, Col. Thomas W. *History of Lycoming County Pennsylvania*. Indianapolis: Historical Publishing Company, 1929.

Meagher, John. *History of Tioga County, Pennsylvania (Morris Township section)*. Chicago: R. C. Brown and Company, 1897.

Meginness, John F. *History of Lycoming County, Pennsylvania*. Chicago: Brown, Rink and Company, 1892.

Stevenson, Harry Sr. *History of Little Pine Valley*. Camp Hill, Pennsylvania: Plankis Suburban Press, 1992.

Stewart, D. J. *History of Lycoming County PA Illustrated*. Philadelphia: J. B. Lippincott and Company, 1876.

Taber III, Thomas T. *Sunset Along Susquehanna Waters*. Muncy, Pennsylvania: Self-published, 1972.

Welshans, Wayne O. *Torbert Village on Pine Creek*. Jersey Shore, Pennsylvania: Self-published, 1993.

DISCOVER THOUSANDS OF LOCAL HISTORY BOOKS FEATURING MILLIONS OF VINTAGE IMAGES

Arcadia Publishing, the leading local history publisher in the United States, is committed to making history accessible and meaningful through publishing books that celebrate and preserve the heritage of America's people and places.

Find more books like this at
www.arcadiapublishing.com

Search for your hometown history, your old stomping grounds, and even your favorite sports team.